FIRST LADIES
of the UNITED STATES

★ ★ ★ ★ ★ ★ ★

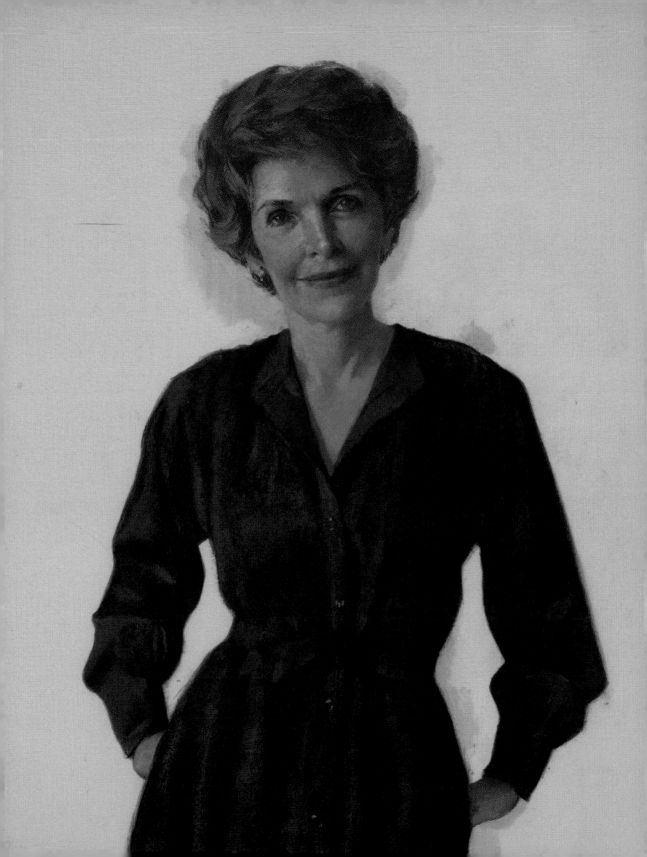

FIRST LADIES
of the UNITED STATES

★ ★ ★ ★ ★ ★ ★ ★ ★ ★ ★ ★ ★ ★

NATIONAL PORTRAIT GALLERY

Gwendolyn DuBois Shaw

Published in
association with the
National Portrait Gallery

Smithsonian Books
Washington, DC

Abigail Adams.
1809.
aged 65.

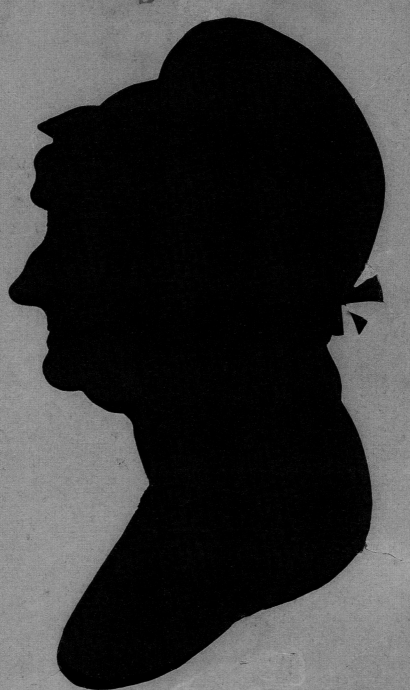

We are grateful for the generous support of those donors whose gifts were received through August 6, 2020, and to all those whose gifts followed.

Morgan Stanley

Jonathan and Nancy Lee Kemper

John H. Simpson Charitable Trust

Terra Foundation for American Art

———

The Honorable Joseph and Alma Gildenhorn

Mr. and Mrs. John Daniel Reaves

Dr. Paul and Mrs. Rose Carter

Ronnyjane Goldsmith

Susan and David McCombs

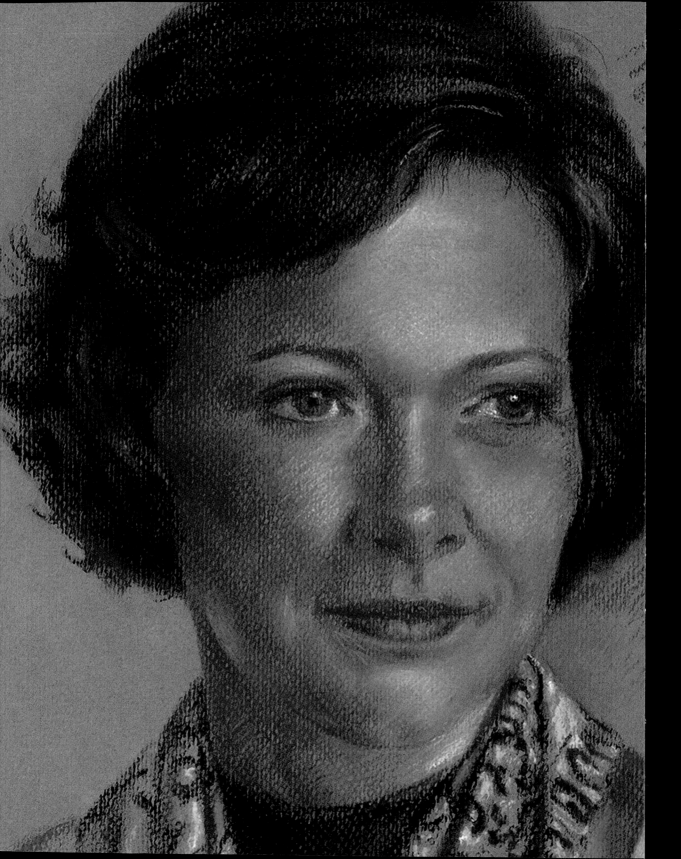

CONTENTS

The National Portrait Gallery, with its mission to tell the history of the United States through the images and biographies of those who have contributed to its formation, development, and present reality, is a museum of history and art, whose centerpiece has always been *America's Presidents*. Today, however, perhaps as a reflection of the growing recognition of contributions made by women, the portraits of the nation's first ladies have become the most requested by the public, and as a result, the temporary exhibition *Every Eye Is Upon Me: First Ladies of the United States* will precede a permanent display of first lady portraits to complement *America's Presidents*. This publication serves as a handbook of the museum's first ladies' collection and will provide a deeper dive into the women—thus far—who have served their nation from within the White House.

Most of the portraits of presidents and first ladies in the museum's collection have been acquired as gifts or purchases, but in 1994, the Portrait Gallery commissioned artist Ronald Sherr to paint President George H. W. Bush. In an era when portraiture was becoming less popular, the museum recognized the importance of artistically significant representations of presidents, and a decade later, when the commission for a portrait of President Bill Clinton was being initiated, the museum chose to expand this practice to include first ladies.

Ginny Stanford's 2006 portrait of Hillary Rodham Clinton became the first commissioned portrait of an American first lady to enter into the museum's collection. Two years later, in 2008, Aleksander Titovets was commissioned to paint First Lady Laura Welch Bush, and in 2018, Amy Sherald completed her commissioned painting of First Lady Michelle LaVaughn Robinson Obama, who had left the White House the previous year. President Donald Trump and First Lady Melania Knauss Trump are expected to follow this tradition and sit for commissioned portraits when they leave the White House.

The insightful essay by Gwendolyn DuBois Shaw and the book's catalogue entries demonstrate how deeply the nation's first ladies have affected American history and culture. They are, of course,

tasked with picking out place settings and hosting parties, but beyond the walls of the White House, each one of them has left an indelible mark. Whether it was Dolley Payne Todd Madison, who brought together politicians on opposing sides to compromise on public policies; Eleanor Roosevelt, who served as the first chair of the United Nations Commission on Human Rights; or Hillary Rodham Clinton, who held the office of US secretary of state, first ladies have often demonstrated political savvy. They have also drawn attention to important social issues, altering the ways in which Americans think about themselves and one another. Lucy Ware Webb Hayes supported temperance. Rosalynn Smith Carter offered nonjudgmental support of mental illness, and Nancy Davis Reagan sought to decrease substance abuse through her "Just Say No" campaign.

As the incomparable Betty Bloomer Ford noted in 1975, "Why should my husband's job, or yours, prevent us from being ourselves? Being ladylike does not require silence." The insights and experiences of first ladies have helped advance women's social and political independence. Today, as we recognize the eventuality of having a "first spouse" and as we have come to not only accept—but expect—first ladies to serve as leaders, we can only begin to imagine how their roles—and their portraits—will develop into the future.

I extend special thanks to the National Portrait Gallery's Senior Historian Gwendolyn DuBois Shaw, the book's author, who also organized the exhibition *Every Eye Is Upon Me: First Ladies of the United States*. We are grateful to those who lent objects to the show and to those who, over the years, have given works to the museum. The National Portrait Gallery has received financial support from several generous donors. Particular thanks go to Morgan Stanley; Jonathan and Nancy Lee Kemper; the John H. Simpson Charitable Trust; the Terra Foundation for American Art; The Honorable Joseph and Alma Gildenhorn; Mr. and Mrs. John Daniel Reaves; Dr. Paul and Mrs. Rose Carter; Ronnyjane Goldsmith; Susan and David McCombs; and the members of the Portrait Gallery Commission.

Kim Sajet

Director, National Portrait Gallery

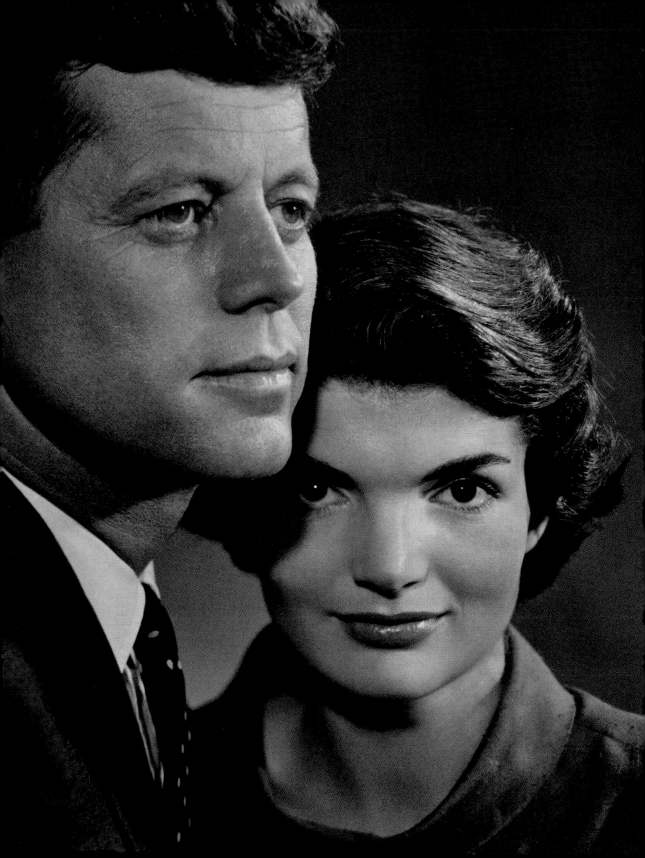

Gwendolyn DuBois Shaw

"I very well know every eye is upon me, my dear mother,
and *I will behave accordingly.*"

Julia Gardiner Tyler[1]

When Julia Gardiner (1820–1889) married President John Tyler in 1844, she was no stranger to scrutiny. As a beautiful, confident, and exceptionally wealthy young woman who came of age in East Hampton, New York, during the 1830s, Gardiner was dubbed the "Rose of Long Island" following her social debut. But in 1840, her popularity turned to notoriety after she posed for a newspaper advertisement touting a discount department store in Manhattan: "I'll purchase at Bogert and Mecamly's, No. 86 9th Avenue," the nineteen-year-old declared. "Their Goods are Beautiful & Astonishingly Cheap" (fig. 1). To mitigate the social stigma that ensued, Mr. and Mrs. Gardiner whisked their wayward daughter off for a grand tour of Europe that included an audience with Pope Gregory XVI. A few years later, after meeting and marrying the tenth president, Julia Gardiner Tyler sought to reassure her mother that she would rise to the occasion and fill the highly public role that she was assuming as the hostess of official White House receptions and state dinners.

John Fitzgerald Kennedy and Jacqueline Lee Bouvier Kennedy (detail)

Yousuf Karsh (1908–2002)
Gelatin silver print, 12⅜ × 10⅜ in. (31.4 × 26.3 cm), 1957
National Portrait Gallery, Smithsonian Institution;
gift of Estrellita Karsh, in memory of Yousuf Karsh
NPG.2012.77.61

Today, few would argue that the role of first lady of the United States is one of the most prominent social positions in the world. Its evolution has followed a remarkable course since the founding of the country. The European social milieu from which the United States emerged at the end of the eighteenth century required the framers of the Constitution to give careful consideration to the choice of a president as the nation's chief executive, but they seem to have given little attention to outlining a role for the president's spouse. As these men conceived the structures for the new nation's governance as the province of male executives, male legislators, and male jurists, perhaps it went without saying that the president's wife (because of course the president would be a man) would behave as all wives of that period were expected to: by raising children, running a home, and entertaining guests. And just as the framers of the Constitution did not see a need to grant an official title to the president's wife, neither did they see the need to commemorate the contributions of most of these women with official portraits to be hung in executive residences or government buildings.

How then did the first ladies of the United States come to be represented in private, popular, and official portraiture over the past 250 years? What can we learn about these women—their roles, their personalities, and their public and private lives—through portraiture? Representations of first ladies have taken the form of paintings, drawings, cut paper silhouettes, photographs of various kinds, and more rarely, sculptures. Two of the earliest first ladies, Martha Washington and Dolley Madison, were represented frequently in "official" painted portraits and popular prints. In contrast, not one verifiable painting of Mary Todd Lincoln (1818–1882) exists, whereas there are dozens of photographs of her, underscoring the effects that the advent of photography, in 1839, had on portraiture.[2] The first lady's image—across media, over time, and as it circulated both publicly and privately in the United States—is the focus of this book.

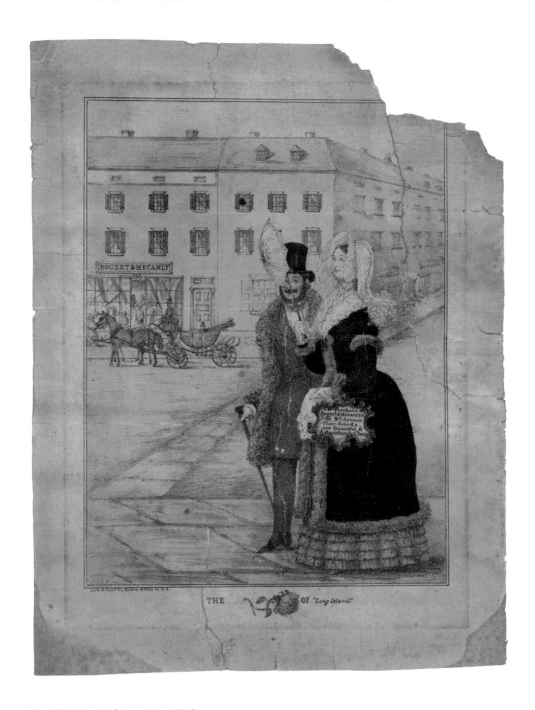

Fig. 1. *The "Rose" of Long Island*, 1840
Alfred E. Baker
Lithograph, 13¾ × 10¾ in. (34.9 × 27.3 cm)
Museum of the City of New York; gift of **Miss Sarah Gardiner, 1939**

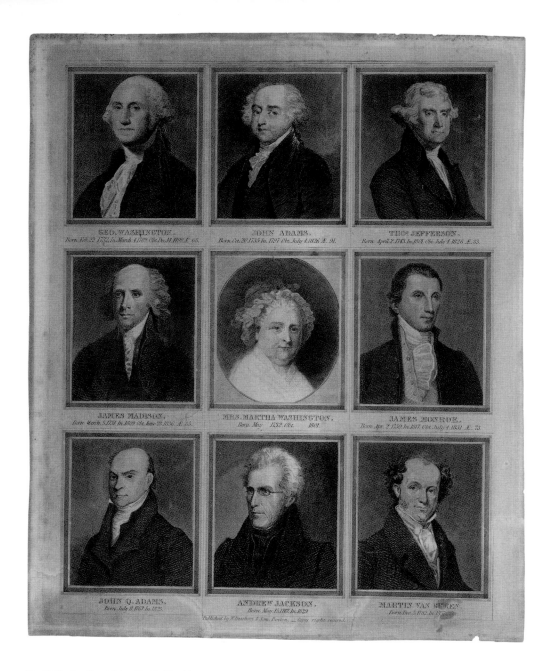

Fig. 2. Martha Dandridge Custis Washington
with the first eight US presidents, c. 1840
Nathaniel Dearborn
Engraving, 12³⁄₁₆ × 10¹⁄₁₆ in. (30.9 × 25.6 cm)
National Portrait Gallery, Smithsonian Institution
NPG.99.135

George Washington's wife, Martha Dandridge Custis Washington (1731–1802), is now regarded as the nation's inaugural "first lady," but during her lifetime, she was hailed by the citizens as "Lady Washington," and her role was viewed as largely ornamental. Despite the official ambiguity of her position, today her place in the formation of a national identity is widely considered of almost equal importance to her husband's in the establishment of the presidency. Just as George Washington became known as the *pater patriae*, or father of the nation, Martha Washington soon became recognized as the country's matriarch, in a process of veneration that continued throughout the nineteenth century. For example, a popular print from around 1840 shows her portrait front and center, surrounded by likenesses of the first eight presidents, as though she were the sun around which their planets revolved (fig. 2). And in 1886, the United States Department of the Treasury began issuing $1 silver certificates with an engraving of Martha Washington's face that was based on a posthumous painting of her by the French artist Charles Jalabert. To date, she remains the only woman who has appeared on US paper currency.[3]

Part of Martha Washington's centrality to the metaphorical and social birth of the nation may have stemmed from her reputation as an able plantation manager and skilled hostess, the second role being one that was essential to the patriarchal structures of eighteenth- and nineteenth-century life. However, in October 1789, writing to her niece, Frances "Fanny" Bassett, she described feeling constrained after ten months of living in the president's house (then in New York)[4]: "I live a very dull life hear [*sic*] and know nothing that passes in the town— I never goe to the publick place—indeed I think I am more like a state prisoner than anything else, there is certain bounds set for me which I must not depart from—and as I can not doe as I like I am obstinate and stay at home a great deal."[5] That Christmas, she was still adjusting to the position: "The difficulties which presented themselves to view upon [George's] first entering upon the Presidency, seem thus to be in some measure surmounted: it is owing to this kindness of our numerous

friends in all quarters that my new and unwished for situation is not indeed a burden to me," she wrote to her friend Mercy Otis Warren. "When I was much younger I should, probably, have enjoyed the inoscent gayeties of life as much as most my age;—but I had long since placed all the prospects of my future worldly happyness in the still enjoyments of the fireside at Mount Vernon."[6]

Many subsequent first ladies found the role to be an all-consuming one that temporarily subordinated their individuality. "There was a sense of detachment—this was I and not yet I," lamented Grace Anna Goodhue Coolidge (1879–1957). "This was the wife of the President of the United States, and she took precedence over me; my personal likes and dislikes must be subordinated to the consideration of those things which were required of her."[7] Others have been as deeply invested in politics as the president with whom they are associated—or more so. Sarah Childress Polk (1803–1891), for example, declared, "If I should be so fortunate as to reach the White House, I expect to live on twenty-five thousand dollars a year, and I will neither keep house nor make butter."[8] And when she and her husband occupied the White House from 1845 to 1849, she indeed proved to be much more interested in politics than in domestic activities. Polk spent most of the period of the Mexican-American War (1846–48) conversing with her husband's political allies, helping him write speeches, and attending cabinet meetings.

Much of what Sarah Polk learned about statecraft during her time in the White House came from her close friendship with former first lady Dolley Payne Todd Madison (1768–1849), who was supremely adept at making political maneuvering the central point of the social occasions that she hosted. In fact, many presidents' wives of the nineteenth and early twentieth centuries had significant political goals that they sought to engage through the alliances made with the men they married. Mary Lincoln not only came from a higher social class than her husband, she also shared similar political ambitions—ones that, as a woman, she was precluded from realizing on her own.

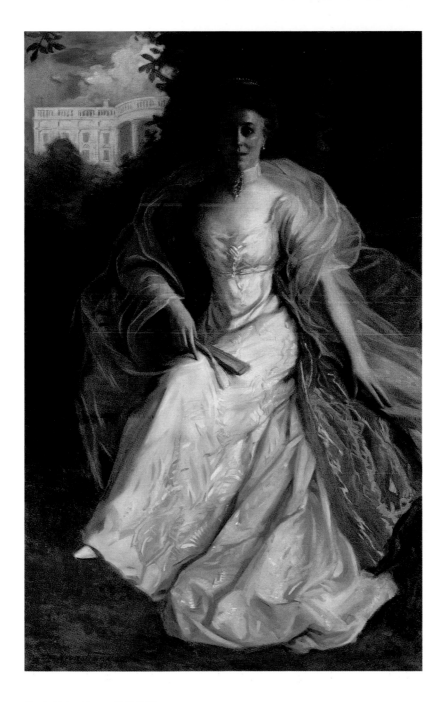

Fig. 3. *Helen Herron Taft*, 1910
Bror Kronstrand
Oil on canvas, 76¼ × 46¼ in. (193.7 × 117.5 cm)
The White House

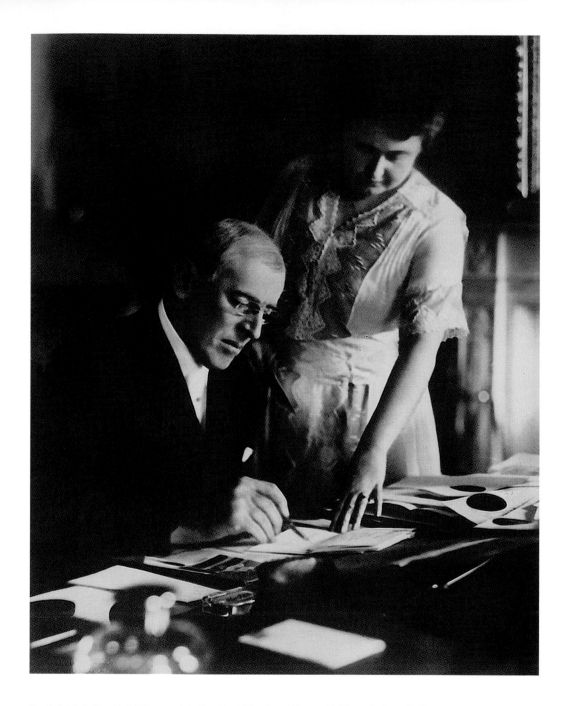

Fig. 4. Edith Bolling Galt Wilson assists President Woodrow Wilson with his work, June 1920
Harris & Ewing, Washington, D.C.
Gelatin silver print, 9¹³⁄₁₆ × 8¼ in. (25 × 21 cm)
Prints and Photographs Division, Library of Congress, Washington, D.C.

Similarly, Helen "Nellie" Herron Taft (1861–1943), the wife of President William Howard Taft, who served from 1909 to 1913, recalled that she "had always had the satisfaction of knowing almost as much as he about the politics and the intricacies of any situation in which [the president] found himself, and my life was filled with interests of a most unusual kind."[9]

An enigmatic portrait of Nellie Taft, which is in the collection of the White House, shows her seated in a garden with the presidential mansion in the distance (fig. 3). Painted by the Swedish artist Bror Kronstrand during his 1910 tour of the United States, the picture emphasizes the first lady's cosmopolitan elegance and proprietary attitude toward the White House and its grounds. Enamored with superlatives, and perhaps thinking of Taft's regal bearing in particular, Kronstrand declared to the press that "the American woman" was "more beautiful than the most beautiful woman I have painted!"[10] Florence Mabel Kling Harding (1860–1924), the wife of President Warren G. Harding, who had helped him manage a newspaper in private life, once bragged: "I know what's best for the President. I put him in the White House. He does well when he listens to me and poorly when he does not."[11]

Although Florence Harding, Nellie Taft, Sarah Polk, and Dolley Madison were confident about their roles as Washington hostesses and politicos, other first ladies have been deeply ambivalent, even profoundly uninterested, in the role that they were expected to fulfill. This was the case for Ellen Louise Axson Wilson (1860–1914), the first wife of Woodrow Wilson, who in 1913 wrote to outgoing President William H. Taft, "I am naturally the most [socially] unambitious of women and life in the White House has no attractions for me."[12]

Just as many presidents' wives have had their own personal political aspirations, others like Mary Lincoln also brought wealth and class position to their marital unions. When Chester B. Arthur married Ellen Lewis Herndon Arthur (1837–1880) in 1859, he joined the company of New York's most prominent families, including the Vanderbilts, Astors, and Roosevelts. Furthermore, his young bride had already inherited tremendous wealth after her father, the naval officer

William Lewis Herndon, went down with his ship, the SS *Central America* (Ship of Gold).[13] Her social position and inheritance greatly aided her husband's political goals.

If a first lady's intelligence and interest in politics could be aids to a president, they could also be the source of potential conflict. A photograph from 1920 of Edith Bolling Galt Wilson (1872–1961), standing at her husband President Woodrow Wilson's side while he works at his desk, hints at the unusual work arrangement that arose following the Paris Peace Conference of 1919, when President Wilson suffered a debilitating stroke that left him partially paralyzed (fig. 4). Rather than reveal the extent of his illness to the public, Edith Wilson isolated him from even his cabinet members and only allowed his doctor to enter his bedchamber during his initial convalescence. Rumors about the president's condition abounded while the first lady acted as gatekeeper, carefully choosing which pieces of business to share with him. Edith Wilson soon incurred the suspicion of both his staff and his political opponents when she began to sift through matters of state in order to determine what merited her husband's personal attention. "So began my stewardship," she later wrote. "I studied every paper, sent from the different Secretaries or senators, and tried to digest and present in tabloid form the things that, despite my vigilance, had to go to the President. I myself never made a single decision regarding the disposition of public affairs. The only decision that was mine was what was important and what was not, and the very important decision of when to present matters to my husband."[14]

Caring for the health of their husbands has been one of the primary duties and points of distraction for many first ladies, sometimes limiting their abilities to have their portraits made. "[President Theodore Roosevelt's] illness and the countless other interruptions made it very hard for [First Lady Edith Kermit Roosevelt] to have the requisite number of sittings," Isabella ("Belle") Hagner, the first White House social secretary, wrote about painter Cecilia Beaux's efforts to make a double portrait of Edith Roosevelt (1861–1948) and her daughter, Ethel (see p. 121). "Poor Miss Beaux was distracted, and Miss Bessie Kean, sister of the

Senator [John Kean of New Jersey], being about the same figure as Mrs. Roosevelt, frequently came to the White House and posed in Mrs. Roosevelt's gown, which helped speed the good work."[15]

Edith and Theodore Roosevelt's niece, the future First Lady Anna Eleanor Roosevelt (1884–1962), discovered her own political skills in part because her husband Franklin Delano Roosevelt's mobility had been impacted by a bout with polio in 1921. After she and FDR entered the White House in 1933, she often served as his "legs," traveling where he could not and helping to shape administration policy as a result. She held regular press conferences, penned a daily newspaper column, and earned her own money as the host of a weekly radio show.

More recent first ladies have also served as official surrogates for the president, standing in at ceremonial occasions and other events when the president has been unable to attend, which was the case in 2018 when first lady Melania Knauss Trump (b. 1970) represented the White House at the funeral of former first lady Barbara Pierce Bush (1925–2018). In 1977, when President Jimmy Carter was too busy to leave the country for an extended goodwill tour, Eleanor Rosalynn Smith Carter (b. 1927) made a thirteen-day trip to seven Latin American countries to meet with heads of state and discuss substantive issues with each of them. She received a warm reception and glowing reviews from those she encountered, including the foreign minister of Peru; he was pleasantly surprised that she was "much better informed than I had thought—far more direct" and "the perfect ambassador between the United States and Latin America."[16]

First ladies frequently use their position to advocate for policies put forward by their husbands, and some have gone on to become powerful political figures in their own right. Arguably, attempts at political and legislative involvement by a first lady peaked in the late twentieth century, when, as first lady, Hillary Rodham Clinton (b. 1947) was tasked by her husband with formulating a plan for health care reform. Despite the roadblocks that she encountered with these efforts, Clinton continued her political career after her husband's second term ended.

Fig. 5. Campaign button featuring Pat Nixon, 1968 National Portrait Gallery, Smithsonian Institution

She ran successfully to become a US senator from New York, and later, she went on to become the US secretary of state under President Barack Obama. In 2016, Clinton became the first woman to win the presidential nomination of a major party when she was elected to serve as the Democratic nominee.

In many ways, Hillary Clinton's political aspirations as first lady were built upon the policy achievements of her predecessors. In the 1960s, for example, Claudia "Lady Bird" Taylor Johnson (1912–2007) initiated the Highway Beautification Act, which focused on urban renewal and planting wildflowers alongside the nation's highways (see p. 147). "Though the word *beautification* makes the concept sound merely cosmetic," Johnson explained, "it involves much more: clean water, clean air, clean roadsides, safe waste disposal and preservation of valued old landmarks as well as great parks and wilderness areas."[17]

Since the mid-twentieth century, most first ladies have been campaign trail surrogates, actively involved in their husband's election. Lady Bird Johnson made a whistle-stop tour of the South by train on the "Lady Bird Special" to help win back white southern voters who had become disaffected by President Lyndon B. Johnson's support of anti-racist, integrationist policies and his signing of the Voting Rights Act of 1965. As the twentieth century ended, the faces of present and aspiring first ladies began appearing on campaign buttons: "Pat (Nixon) for First Lady," "Betty Ford for First Lady in '76," "Re-elect Rosalynn Our First Lady," and "Our First Lady, Nancy Reagan" were frequent sights on the lapels of politically engaged citizens as elections came and went in the 1970s and 1980s (fig. 5).

During her brief time as first lady, Elizabeth "Betty" Anne Bloomer Ford (1918–2011) improved the public's understanding of breast cancer and its available treatments. Her willingness to raise awareness through her personal battle with the disease, while living in the White House, inspired more open discussions on the topic. Furthermore, Ford's

subsequent advocacy for alcohol and substance abuse treatment after leaving Washington has forever changed perceptions of addiction. Rather than viewing addiction as a shameful personal failing, it is now widely understood as a disease that is often brought on by social and genetic causes.

Hillary Clinton's predecessors, notably Johnson and Ford, had used the platform of being first lady to help improve the lives of Americans, and their efforts led to the presumption that subsequent first ladies would conceive and support initiatives to benefit the nation in some way. At the same time, the expectation that a first lady would actively advocate for a social cause came as the responsibilities of mothering large families began to recede into the past. Many wives of nineteenth- and early-twentieth-century presidents gave birth to at least five or six children during their lifetimes, as was the case for Hannah Hoes Van Buren (1783–1819), Margaret "Peggy" Mackall Taylor (1788–1852), and Edith Roosevelt (fig. 6). Other White House families were even larger. Lucy Ware Webb Hayes (1831–1889) had eight children, and Anna Tuthill Symmes Harrison (1775–1864) was the mother of ten, while John Tyler

Fig. 6.
The Roosevelt Family, 1903
Pach Brothers Studio
Gelatin silver print, 2¹⁵⁄₁₆ × 5⁷⁄₁₆ in. (7.5 × 13.8 cm)
National Portrait Gallery, Smithsonian Institution; gift of Joanna Sturm
NPG.81.157

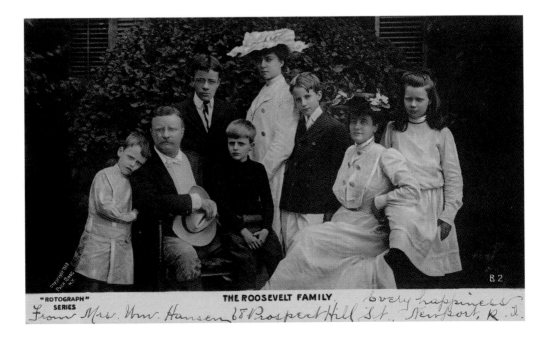

fathered seven children with his first wife, Letitia Christian Tyler (1790–1842), before having seven more with his second wife, Julia Gardiner Tyler. Sarah Polk is the only president's wife to have remained childless throughout her life.

Just as they may have given birth many times, so, too, did many first ladies suffer the loss of children, to disease and accidental death. In the nineteenth century, when infant mortality was high, it was not unusual for children to die from communicable diseases before their second birthday. Unsurprisingly, mourning the loss of a child significantly impacted one's abilities to serve as a cheerful hostess and helpmate. Margaret Taylor had lost four of her six children to malaria by the time she arrived at the White House, and she had no interest in serving as the nation's official hostess. By the time Jane Means Appleton Pierce (1806–1863) took on the role of first lady in 1853, all three of her children had died. Benny, her beloved twelve-year-old son, was killed before her eyes in a horrific train accident that occurred a few weeks before his father's inauguration (fig. 7). Mary Lincoln was devastated by the loss of three of her four sons, including Willie, who died during the Civil War. Frances Folsom Cleveland's (1864–1947) much-celebrated daughter Ruth, who was born in the White House and for whom the candy bar "Baby Ruth" was named, died of diphtheria at age twelve. Ida Saxton McKinley (1847–1907) never recovered from the loss of her two young daughters many years before becoming first lady. Later in life, after her brother had been shot to death by a scorned lover and after her husband had been cut down by an assassin's bullet, she is said to have declared, "I shall never be happy again."

Modern first ladies also lost young children during their lifetimes, and the commonness of such loss does nothing to make it less painful. Jacqueline "Jackie" Bouvier Kennedy (1929–1994) endured a miscarriage and a stillborn daughter before arriving at the White House in 1961 with her young children Caroline and John Jr. in tow, and her son Patrick died less than forty-eight hours following his premature birth in August 1963. Before the conclusion of that year, she witnessed her husband's

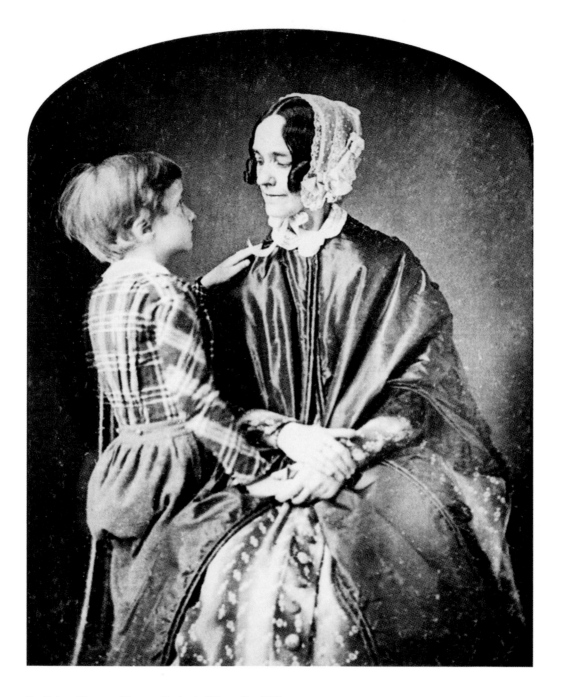

Fig. 7. Jane Pierce and her son Benjamin ("Benny"), c. 1850
Unidentified photographer
Daguerreotype
The Pierce Brigade / The Pierce Manse

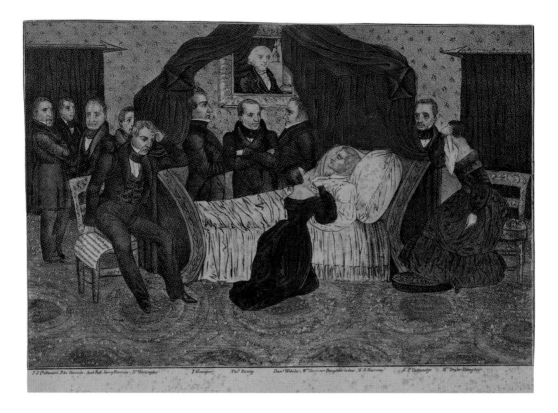

Fig. 8. *Death of
Harrison*, 1841
Henry R. Robinson
Hand-colored
lithograph,
10⅝ × 13⅛ in.
(27 × 33.4 cm)
National
Portrait Gallery,
Smithsonian
Institution
NPG.84.183

assassination as she rode with him through the streets of Dallas. Lady
Bird Johnson, who was with the Kennedys that tragic day, later recalled
the newly widowed first lady's remarkable strength throughout the
funeral and its procession: "I wanted to cry for them and with them,
but it was impossible to permit the catharsis of tears," she wrote in her
diary. "I don't know quite why, except that perhaps continuity of strength
demands restraint. Another reason was that the dignity of Mrs. Kennedy
and the members of the family demanded it."[18]

The death of a president while in office, from natural causes or
assassination, affected the lives of eight first ladies and an equal number
of vice presidents' wives who were suddenly and unceremoniously thrust
into a new role. The fear of death undoubtedly afflicted them all. "Oh how
I wish he was out of political life," a concerned Jane Pierce exclaimed
about her husband Franklin Pierce. "How much better it would be for him
on every account!"[19] While living in the White House, illness took the lives

26

of presidents William H. Harrison (fig. 8), Taylor, Harding, and Franklin D. Roosevelt; assassins' bullets felled presidents Lincoln, Garfield, McKinley, and Kennedy, and wounded President Reagan during the first year of his presidency. "How was I ever going to live through eight years of this?" Nancy Davis Reagan (1921–2016) remembered asking herself. "Night after night, I lay beside my husband and tried to drive these gruesome thoughts from my mind. Ronnie slept, but I could not. . . . When you are as frightened as I was, you reach out for help and comfort in any direction you can. I prayed what seemed like all the time, more than I ever had before."[20] Following the attempt on her husband's life in March 1981, Nancy Reagan turned to astrology for comfort, anti-drug activism for a sense of purpose, and to White House social events for distraction, hosting over fifty state banquets in honor of foreign heads of state over two terms.

While Nancy Reagan may have used a busy social calendar to preempt worries about her husband's safety, the task of entertaining guests has been paramount in the lives of almost every first lady since Martha Washington's day. The abilities required of a good White House hostess in the nineteenth century mostly relied on her knowledge of etiquette and her personal experience of moving in the higher-level echelons of upper-class society. Many early first ladies had previously spent time at European courts and had a model from which to draw as the White House began functioning as a sort of court palace for the president. Similarly, Washington City, chosen as the location of the capital of the new nation in 1790, began to function as Versailles had for the French kings, as a place to gather the federal courtiers. In 1877, Eliza Bisbee, an author and editor, and women's rights activist, observed: "The life of a lady in society at Washington is exceedingly onerous, and more especially so if she be the wife of any official."[21]

Upper-class, nineteenth-century social etiquette in the new United States, like that in Britain or continental Europe, required that gatherings involving the polite social interaction of ladies and gentlemen (not to be confused with the men and women of the lower classes) adhered to

a strict set of expectations and actions. Chief among these expectations was that a "well-bred lady" would function as the hostess, or director, of activities such as formal dinners and balls. These occasions were prime opportunities for presidents to forge alliances, garner support for legislative agendas, and advance re-election campaigns. Before the establishment of an official White House social secretary in 1901, when First Lady Edith Roosevelt hired Belle Hagner to fill the role, the first lady was expected to send invitations; select an appropriate dinner menu using seasonal ingredients and special delicacies; choose the wines (or opt to exclude alcohol from the table entirely); and assign appropriate dinner partners (of the opposite sex) for each guest to ensure an advantageous distribution of personalities. The first lady would greet invited guests as they arrived at the event and then help control the flow of the evening's conversations as she circulated amongst the room and introduced guests to one another. "To entertain well, you must forget that you are so engaged and your company will feel perfectly at their ease and forget they are visiting," explained First Lady Louisa Catherine Johnson Adams (1775–1852), the wife of John Quincy Adams, who spent many years of their marriage engaged in social diplomacy at several royal and imperial courts on the European continent.[22]

Large White House gatherings demanded both a theoretical understanding of the various genres and a lot of practice in execution. Traditional balls required that hostesses oversee the selection and order of the music to be played, which would be printed on dance cards that helped attendees manage their partners for the evening. The New Year's Day "levees," or public receptions, which were held annually at the White House until Herbert Hoover discontinued them in 1932, typically entertained thousands of people. For these occasions, the first lady often relied on the assistance of other women, including family members and friends, to greet guests, direct servants, and keep to the schedule for the evening. However, some first ladies, such as Mary Lincoln, were said to be loath to share the spotlight and pushed back when others tried to help with hostessing duties.[23] Commemorated in a popular print

ABRAHAM LINCOLN'S LAST RECEPTION.
RESPECTFULLY DEDICATED TO THE PEOPLE OF THE UNITED STATES

following President Lincoln's assassination in April 1865, the New Year's Day levee of that year hosted by Mary Lincoln was to be her husband's last (fig. 9). Here, we see President Lincoln shaking the hand of Julia Dent Grant (1826–1902), whose husband General Ulysses S. Grant stands to the right, wearing his Union Army uniform. This print in which three presidents are shown—Andrew Johnson stands between President Lincoln and Julia Grant—was probably created using photographs of the notable figures rather than drawings taken from life. This technique accounts for General Grant's direct engagement with our gaze and the numerous other directions in which the members of the crowd are looking.

In addition to hosting annual events like the New Year's Day levees, residents of the White House have a long history of welcoming guests for dinners and large banquets. Some presidents, like Calvin Coolidge, are said to have enjoyed participating in menu selections, but most

Fig. 9. *Abraham Lincoln's Last Reception*, 1865 Anton Hohenstein Hand-colored lithograph, 24 × 34⅜ in. (61 × 87.3 cm) Prints and Photographs Division, Library of Congress, Washington, D.C.

relied on their first ladies to supervise the arrangements. The practice of holding formal state banquets at which foreign heads of state were honored only began in 1874, when President Ulysses S. Grant and First Lady Julia Grant invited King Kalākua and Queen Kapiʻolani of the Sandwich Islands (now the US state of Hawaiʻi) to the White House. The practice was slow to catch on, and not every president has chosen to hold state dinners at the White House. Regardless, the social tenor set by the occupants of the White House has been a constant subject of comparison and commentary by Washington's "cave dwellers," the nickname given to the city's elites who remain as administrations come and go.

 "During the Eisenhower years, when I first came here," wrote an anonymous Washingtonian in the 1970s, "nobody accused administration officials of risqué behavior. But, my, how they grumbled about the stodginess of the White House social scene. Dullsville was replaced by Camelot when the Kennedys came in. Washington was entranced, intrigued and enlivened by the social style of the young President and his Jacqueline."[24] Jacqueline Kennedy moved easily amongst foreign dignitaries and hosted no fewer than fifteen state banquets in the two years that she and President Kennedy occupied the White House. (And while the country's circumstances were very different during the Great Depression and World War II, President Franklin D. Roosevelt and Eleanor Roosevelt hosted only eleven state dinners over twelve years.) The Kennedys often had live entertainment at these events, inviting sophisticated performers, such as the Joffrey Ballet and members of the National Symphony Orchestra, to appear before their guests. This tradition was carried on by First Lady Lady Bird Johnson and President Lyndon B. Johnson, who hosted seventeen banquets that presented similar performers. The Johnsons sought to add a touch of Americana by bringing in popular acts such as Herb Alpert and the Tijuana Brass and jazz guitarist Charlie Byrd. "The Johnsons set a more down-home and boisterous pace, but it was still judged to be within the Washington tradition," the anonymous Washington social critic continued. "The

Nixons tried hard but it came off as too much pretension, while the Fords' social example was rated as sort of a Grand Rapids version of the LBJ era. The social tone being set by the Carters is more permissive, more do-your-own-thing, than Washington society would like."[25]

As this anonymous insider's assessment demonstrates, the social milieu that the first lady cultivates, with the help of the official social secretary, has long been of great interest; however, it mischaracterizes the state banquets hosted by President Jimmy Carter and First Lady Rosalynn Carter. The Carters hosted forty dinners in just four years—featuring opera stars, notable classical musicians, and members of the National Symphony Orchestra. With performances by Itzhak Perlman, Isaac Stern, and others, these were hardly "do-your-own-thing" events.

The types of grand state banquets that twentieth-century first ladies hosted would have impressed many of their predecessors, but other first ladies, those who were more concerned with negotiating the difficulties of being a woman in a society that treated them first as the property of their fathers and then of their husbands, may have found them to be onerous commitments. Long before Abigail Smith Adams (1744–1818) and her husband, President John Adams, became the first residents of the White House (then known as the President's House), in the fall of 1800, Abigail Adams was advocating for women's rights and increased participation in society beyond the role of hostess. The proto-feminist perspective that she took toward the potential for change in the new nation is often exemplified by her entreaty to her husband during the drafting of the Declaration of Independence in 1776: "I long to hear that you have declared an independency—and by the way in the new Code of Laws which I suppose it will be necessary for you to make I desire you would Remember the Ladies, and be more generous and favourable to them than your ancestors," she wrote. "Do not put such unlimited power into the hands of the Husbands. Remember all Men would be tyrants if they could. If perticuliar care and attention is not paid to the Laidies [sic] we are determined to foment a Rebelion, and will not hold ourselves bound by any Laws in which we have no voice,

or Representation."[26] Regrettably, gender inequality was initially enshrined in the founding documents of the nation, including the Constitution.

The lack of legal rights made women vulnerable to abuse from domestic "tyrants," and the women we include in the category of first ladies were no exception. President Andrew Jackson's wife, Rachel Donelson Robards Jackson (1767–1828), came to their relationship as a refugee from a bad marriage. Her first husband, Lewis Robards, was given to "jealous rages" so terrifying that her family consented to take her back when she fled his household. He continued his sadistic behavior by agreeing to a grant her a divorce but then waiting until after she married Andrew Jackson to file the paperwork. Consequently, she was made into an unwitting bigamist and became the subject of scandal for the rest of her life. Rachel Jackson nonetheless turned her unfortunate experiences into advocacy and supported the temperance movement, which identified alcohol as a fuel for many abusers. While Andrew Jackson was serving as governor of Florida, the stress of her infamous notoriety took its toll and later made her quite reluctant to assume the role of first lady. "I am glad of it for Mr. Jackson's sake, because it is his ambition. For me it is but one more burden," she lamented after learning that her husband had won election to the presidency in 1828. "Even if I was qualified in other ways to do the honors of the White House, my health is not good enough to bear the strain."[27] For many nineteenth-century women, without rights to their own financial independence or to vote in elections, the slow simmer of rebellion persisted.

Those "Laidies" who were determined to exercise personal agency and chart their own paths include many first ladies who have been at the forefront of our changing ideas of women's roles in society. First Lady Dolley Madison is today remembered more for a single act of bravery than for the parties she oversaw as the "Queen of Washington City," the title by which she was affectionately known during her lifetime.[28] In 1814, when the invading British army was about to lay siege to the White House, legend has it that she risked her life to ensure that a copy

of Gilbert Stuart's "Lansdowne" portrait of George Washington was taken to safety (fig. 10). "Our kind friend, Mr. Carroll, has come to hasten my departure, and in a very bad humor with me, because I insist on waiting until the large picture of General Washington is secured, and it requires to be unscrewed from the wall," she wrote to her sister as British forces bore down upon the capital. "This process was found too tedious for these perilous moments; I have ordered the frame to be broken, and the canvas taken out. It is done! and the precious portrait placed in the hands of two gentlemen of New York, for safe keeping. And now, dear sister, I must leave this house, or the retreating army will make me a prisoner in it by filling up the road I am directed to take."[29] Her motivation for crafting this story lay in her deep understanding of the psychological power of representation; if the British captured and publicly destroyed this effigy of the nation's father, then they would gain the mental advantage.

Fig. 10. George Washington, "Lansdowne" Portrait, 1796 Gilbert Stuart Oil on canvas, 97½ × 62½ in. (247.6 × 158.7 cm) National Portrait Gallery; acquired as a gift to the nation through the generosity of the Donald W. Reynolds Foundation NPG.2001.13

Dolley Madison's act to preserve the Lansdowne portrait is proof of the dedication she felt toward her role as a temporary steward of the nation's treasures. Not all first ladies have been as involved in the preservation of the White House and its contents; in fact, several women whom we often include under the designation of first ladies never set foot inside the White House. A number of presidents were widowers—sometimes for months, sometimes for years before they took office—and their late wives have traditionally been referred to as "honorary

first ladies" because of the presumed impact that they had on their husbands.[30] Three first ladies—Letitia Tyler, Caroline Harrison, and Ellen Wilson—died in the White House, and in their absence, other women had to assume their hostessing responsibilities.

When the president's wife predeceased him or when she was unwilling or unable to take on the role of first lady, the required hostess duties were transferred to nieces, daughters, and other women who stepped in to serve the nation. In an era of shorter life expectancy, when people often succumbed to now-treatable diseases and women frequently died in childbirth,

Fig. 11. Alice Hathaway Lee Roosevelt, c. 1880–84 (printed later) Unidentified photographer Photograph, 10 × 7 in. (25.4 × 17.8 cm) Prints and Photographs Division, Library of Congress, Washington, D.C.

such as Theodore Roosevelt's first wife, Alice Hathaway Lee Roosevelt (1861–1884), it is not surprising that such a large number of the nation's early presidents relied upon their sisters, daughters, daughters-in-law, nieces, and colleagues' wives to assume the duties that would otherwise have been expected of their wives (fig. 11).[31]

When the long-widowed Thomas Jefferson assumed the presidency, he tried to avoid mixed social occasions of all kinds and preferred gatherings with like-minded male colleagues to those where political adversaries were present at the same table. And when he could not avoid mixed-gender gatherings, Jefferson often relied on Dolley Madison, the wife of his secretary of state, James Madison, or his eldest daughter, Martha "Patsy" Jefferson Randolph, to shoulder the responsibility of

serving as hostess. No portraits of Thomas Jefferson's wife, Martha Wayles Skelton Jefferson, are believed to exist, but she was said to have resembled her daughter Martha Jefferson Randolph, which seems reasonable.[32] Similarly, no portraits or physical descriptions of Margaret Taylor, the wife of President Zachary Taylor, survive; she had rejected the social duties that were commonly expected of first ladies, asking her daughter Betty Taylor Bliss to serve as the official White House hostess. The recently widowed Andrew Jackson requested that his niece, Emily Donelson, serve as his primary hostess, while the widower Martin Van Buren asked his daughter-in-law Angelica Singleton Van Buren to be the gracious female presence who presided over official social events. And during his presidency, Chester B. Arthur kept a photograph on his bedside table of his beloved and long-departed wife, Ellen, whereas his younger sister, Mary Arthur McElroy, assumed the necessary hostess duties.

Similar arrangements were made by bachelor presidents. James Buchanan never married and relied upon his niece Harriet Lane to serve as his hostess and first lady for his entire term. Grover Cleveland was a bachelor in his late forties when he assumed office in 1885, so his sister, Rose Elizabeth Cleveland, served as the White House hostess following his first inauguration. After the first eighteen months of Cleveland's presidency, however, he married the twenty-one-year-old Frances Folsom, and she took over the first lady duties. In part because she was such a gracious hostess, Frances Cleveland became one of the most celebrated women of the 1880s, having her likeness appropriated by innumerable advertisers who presented her as a social and domestic ideal for aspirational customers (fig. 12).

By the end of the nineteenth century, with the rise of photographic reproduction and the accessibility of cheap chromolithography, representations of first ladies frequently appeared in newspapers and other ephemera. Since then, their fashion and style choices have become popular topics of discussion, especially as the expansion of mass media made news and images more accessible to the broader public. During the twentieth century, when full-color photographic

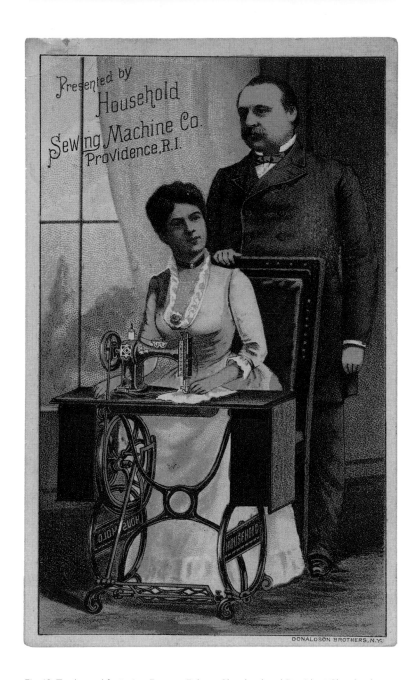

Fig. 12. Trade card featuring Frances Folsom Cleveland and President Cleveland,
Household Sewing Machine Company, c. 1886–90
Donaldson Brothers
Lithograph, 4⅞ × 3 in. (12.4 × 7.6 cm)
National Portrait Gallery, Smithsonian Institution; gift of John O'Brien
NPG.91.114

spreads made magazines more visually entertaining, first ladies became increasingly recognizable subjects. For a general public interested in learning more about these women, *Life*, *Time*, *Vogue*, and *Vanity Fair* gave readers glamorous presentations of first ladies at home in the White House, in daywear, in evening gowns, and with their husbands and families. They were depicted as both relatable and rarified creatures, providing a model for others to follow.

In the 1950s, when Mamie Doud Eisenhower (1896–1979) assumed the role of first lady, *Life* and other photographic magazines were strong influences upon popular perceptions of how women should present themselves and keep their homes (fig. 13). "Of course, being mistress of the White House is a terrific responsibility," Eisenhower explained to reporter Nanette Kuttner in 1952, "and I am truly grateful for my Army wife training."[33] Her homey decorating choices and her penchant for a certain shade of rose, which became known as "Mamie pink," characterized her efforts to make the White House into an ideal home for both her husband and the nation.

Similarly, Nancy Reagan visually distinguished herself by wearing suits and dresses in a color that soon became known as "Reagan Red." Unlike the girlish and feminine Mamie Pink, this undiluted primary color was bold and assertive. By the mid-1980s, Reagan Red had become the favored color of the whole Republican Party (despite its previous and ongoing association with leftist political parties and ideas; think Red China and the "Reds" of Communist Russia in the mid-twentieth century), leading Democratic Party followers to adopt a similarly patriotic shade of blue as their oppositional color. It has been argued that the contemporary shorthand of referring to Republican-voting states as "red states" and those that tend to vote for Democratic candidates as being "blue states" can be traced back to Nancy Reagan's adept use of fire engine red as her personal power color (see p. 157).[34]

While it may not have been Nancy Reagan's initial plan to have her love of red influence the country's political party branding, patriotically minded clothing choices have been made by many first ladies. As first

lady, Jacqueline Kennedy had the majority of her clothes custom-made by Chez Ninon, a New York clothier who received special permission from Parisian fashion houses, such as Chanel and Givenchy, to create replica garments using authentic fabric and buttons that were "made in America." Similarly, as first lady, Michelle LaVaughn Robinson Obama (b. 1964) alternated between off-the-rack clothes, sold by American companies like J. Crew, and more expensive pieces by established designers. She also commissioned emerging talent, such as the Chinese-born, New York City–based Jason Wu, who was just twenty-six when he created the dress that she wore to the 2009 inaugural ball. In 2017, as she began the process of preparing for her official portrait to be made for the National Portrait Gallery, she chose a cotton poplin maxi dress by New York designer Michelle Smith. Patterned with geometric color blocks that are reminiscent of the African American quilting tradition, the dress reminded artist Amy Sherald and Smith of the quilts of Gee's Bend.

Each first lady of the United States has inhabited this complicated and evolving role differently. And how they have all chosen to behave, what they have worn at public events, and the causes they have chosen to champion often receive as much scrutiny as the policies put forward by their husbands. Although she disliked the title First Lady, saying that it sounded like the name for "a saddle horse," Jacqueline Kennedy's short time in the role was characterized for many by her personal composure, elevated aesthetic, and sense of style.[35] However, no matter how appropriate one's behavior or dress, there is rarely a choice made by a first lady that escapes public discussion. "The First Lady is going to be criticized no matter what she does," lamented Barbara Bush. "If she does too little. If she does too much. And I think you just have to be yourself and do the best you can. And so what? That's the way it is."[36] It is easy to imagine that we will soon be reevaluating this role as that of "first spouse." After all, it is likely that in the near future, male life-partners and same-sex companions of presidents will begin to assume this role—with all eyes upon them, too.

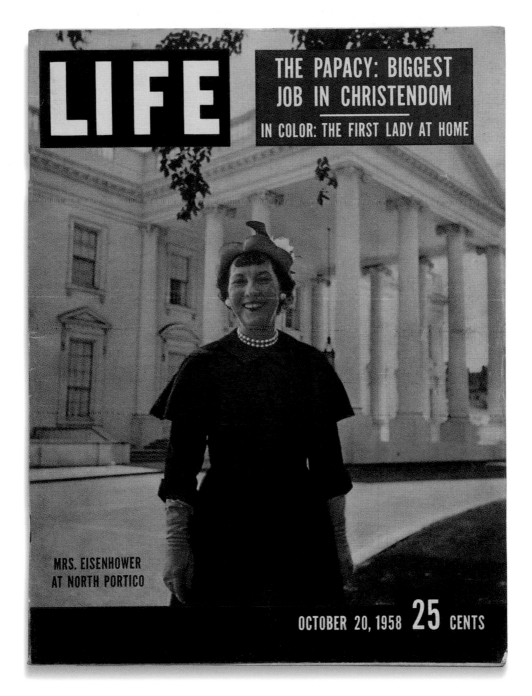

Fig. 13. Mamie Doud Eisenhower featured on the cover of *Life*, October 20, 1958
Photograph by Edward Clark
Magazine, 14 × 10½ in. (35.6 × 26.7 cm)
National Portrait Gallery, Smithsonian Institution

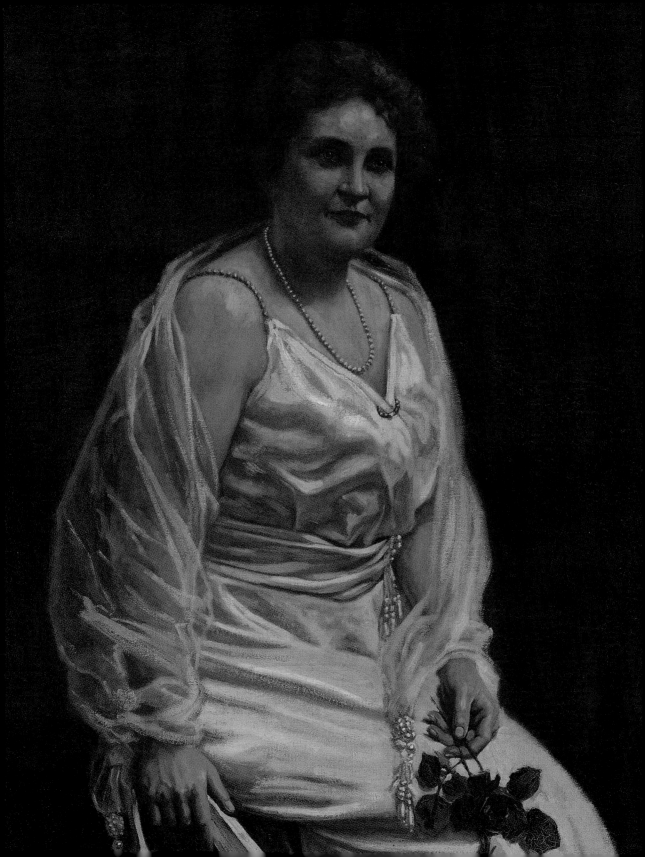

Edith Bolling Galt Wilson (1872–1961) (detail)

——————

Emile Alexay (1891–1949)
Oil on canvas, 46¼ × 31⅝ in. (117.5 × 79.5 cm), 1924
National Portrait Gallery, Smithsonian Institution; gift of Dr. Alan Urdang
NPG.69.43

MARTHA DANDRIDGE CUSTIS WASHINGTON

Martha Dandridge Custis married George Washington in 1759, thirty years before he served as the nation's first president. When the two of them met, her first husband, Daniel Park Custis, had recently died, and she had two young children in tow. Martha Custis's vast wealth made her an attractive prospect for the ambitious George Washington, who had recently served as a colonel in the Virginia militia regiment during the French and Indian War (1754–63). Her property included 17,500 acres of land and over 300 enslaved people, including her own half-sister, Ann Dandridge.[37] A few months after the couple's wedding, they moved to the Washington family's plantation, Mount Vernon, in Northern Virginia.

During the Revolutionary War (1775–83), Martha Washington often accompanied her husband, now a general in the Continental Army, while he lived in the winter encampments. She contributed food, wool, medicine, and other essential supplies and provided a soothing presence for him and his soldiers. In the years that followed the war, she left her pleasant life at Mount Vernon, which was made possible by a large, enslaved workforce, to support George Washington as he fulfilled his responsibilities as president. "I little thought when the war was finished, that any circumstances could possibly have happened, which would call the General into public life again," she wrote her friend Mercy Otis Warren in 1789. "I had anticipated, that from this moment we should have been left to grow old in solitude and tranquility together . . . but in that I have been disappointed . . . yet I cannot blame him for having acted according to his ideas of duty in obeying the voice of his country."[38]

Gilbert Stuart painted Martha Washington from life in 1796, when the presidential couple was living in Philadelphia, which served as the

Martha Dandridge Custis Washington (1731–1802)
Born Chestnut Grove, Virginia

———

Unidentified artist, after Gilbert Stuart
Oil on canvas, 30 × 25½ in. (76.2 × 64.8 cm), c. 1800–50
National Portrait Gallery, Smithsonian Institution
NPG.70.3

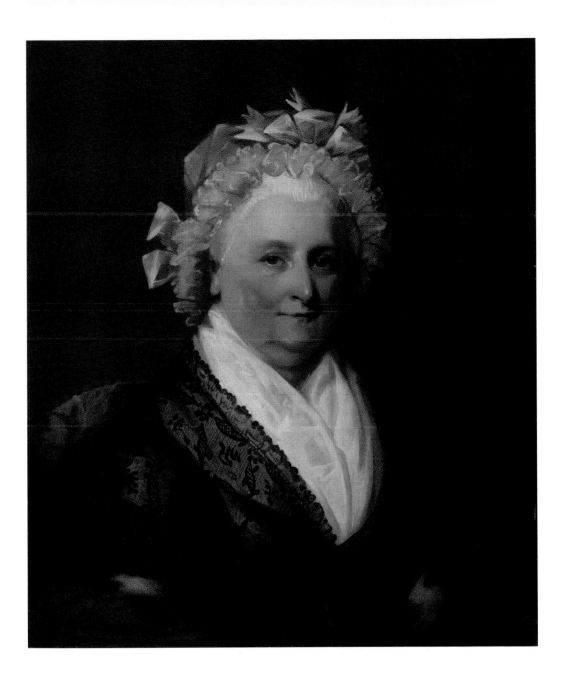

Martha Dandridge Custis Washington
"Athenaeum" Portrait

Gilbert Stuart (1755–1828)
Oil on canvas, 48 × 37 in. (121.9 × 94 cm), 1796
National Portrait Gallery, Smithsonian Institution;
owned jointly with the Museum of Fine Arts, Boston
NPG.80.116

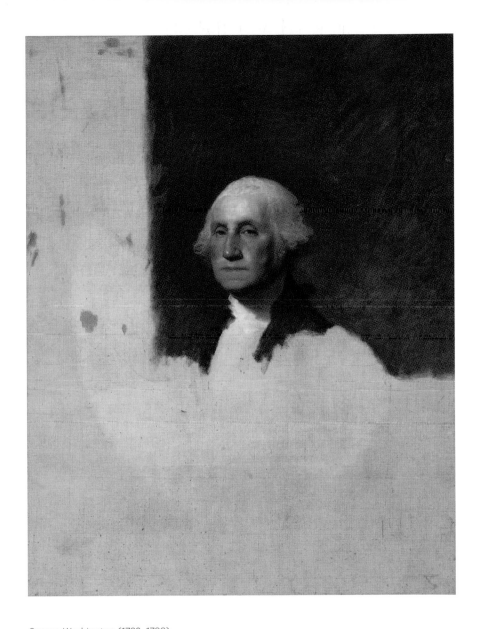

George Washington (1732–1799)
"Athenaeum" Portrait

––––––––

Gilbert Stuart (1755–1828)
Oil on canvas, 48 × 37 in. (121.9 × 94 cm), 1796
National Portrait Gallery, Smithsonian Institution;
owned jointly with the Museum of Fine Arts, Boston
NPG.80.115

nation's capital between 1790 and 1800. The "Athenaeum" portrait, as this work is known, is the pendant, or companion, to a similarly unfinished one of her husband (pp. 44–45). The two paintings were never completed beyond the facial details because they were explicitly intended as representative templates for Stuart to use for subsequent portraits. That they were made as a pair is evidence of the importance that was placed on the couple as the familial heads of the new nation.

After the presidency, George and Martha Washington returned to Mount Vernon to raise her two grandchildren, George Washington "Wash" Parke Custis and Eleanor "Nelly" Custis. As an adult, Wash Custis fathered a daughter named Maria with an enslaved house servant, Arianna Carter. In 1825, he freed Maria, providing her with land from his estate, Arlington, in Virginia. Wash's other surviving daughter, Mary Anna Randolph Custis, went on to marry Robert E. Lee and occupied the nearby mansion house on the property that is now known as Arlington National Cemetery. In this popular print, the Washingtons gather around a map while an enslaved servant, possibly Christopher Sheels, stands at right, alluding to the complex interracial relationships and dependencies that were a part of the family.

The Washington Family

———

David Edwin (1776–1841), after Edward Savage
Engraving, 18⁷⁄₁₆ × 24½ in. (46.8 × 62.3 cm), 1798
National Portrait Gallery, Smithsonian Institution
NPG.79.112

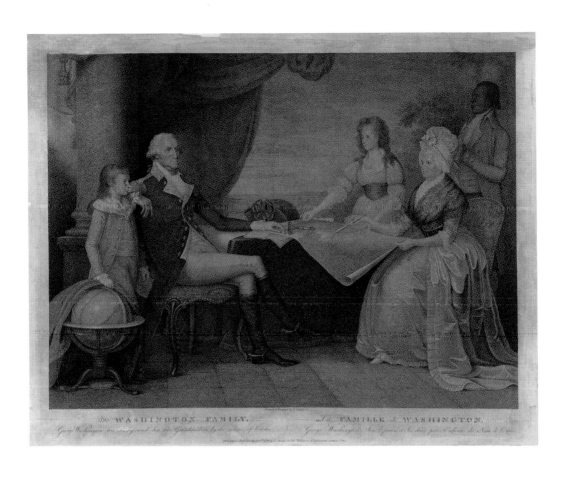

THE WASHINGTON FAMILY.

LA FAMILLE DE WASHINGTON.

George Washington, his Lady, and her two Grandchildren by the name of Custis.

George Washington, Son Épouse et les deux petits Enfants du Nom de Custis.

ABIGAIL SMITH ADAMS

Born in Weymouth, Massachusetts, Abigail Smith Adams was descended from the Quincys, a well-established English family that settled in the colonies in the mid-1600s. Self-assured and confident, she challenged social and political limitations by advocating for women's rights, education, and the abolition of slavery. She readily expressed her opinions in letters to her husband, John Adams, by reminding him to "Remember the Ladies" as he helped to frame the new nation's institutions.[39] Always outspoken, Adams struggled to suppress her opinions when her husband served as president. The public scrutiny that the couple received often left her feeling imprisoned in the presidential mansion in Philadelphia.

This portrait of Adams reveals her elegant and sophisticated comportment. She wears both an imported lace fichu over her bodice and an elaborately patterned scarf of Indian origin about her shoulders, demonstrating her cosmopolitan taste.

As the matriarch of the family dynasty, Adams's insight and intellect inspired future generations. Although she died before her eldest son, John Quincy Adams, became president, she developed a close relationship with his wife, Louisa Catherine Johnson Adams. Two silhouettes of the Adams women survive (see p. 51 and also p. 63).

Abigail Smith Adams (1744–1818)
Born Weymouth, Massachusetts

Unidentified artist
Oil on canvas, 30¼ × 26⁷⁄₁₆ in. (76.9 × 67.2 cm), c. 1795
Collection of the Fenimore Art Museum, Cooperstown, New York;
bequest from the Estate of Frances J. Eggleston, Oswego, New York

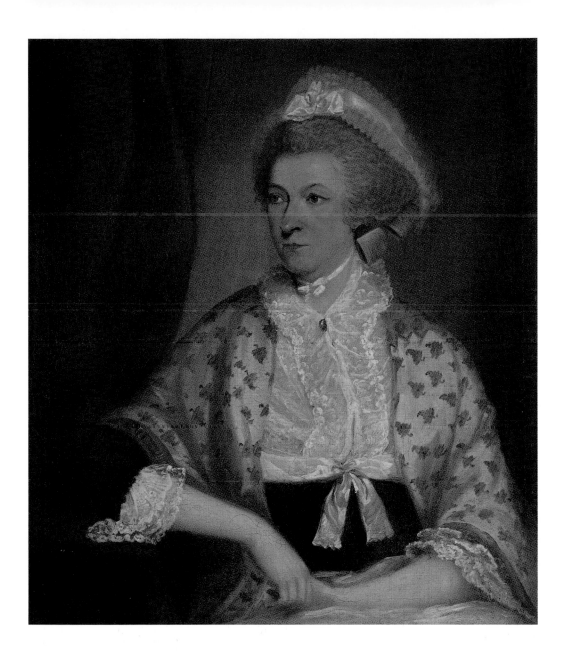

Abigail Smith Adams

———

Attributed to Raphaelle Peale (1774–1825)
Hollow-cut silhouette, 4⅛ × 3⅜ in. (10.4 × 8.6 cm), 1804 (inscribed in 1809)
National Portrait Gallery, Smithsonian Institution
NPG.78.282

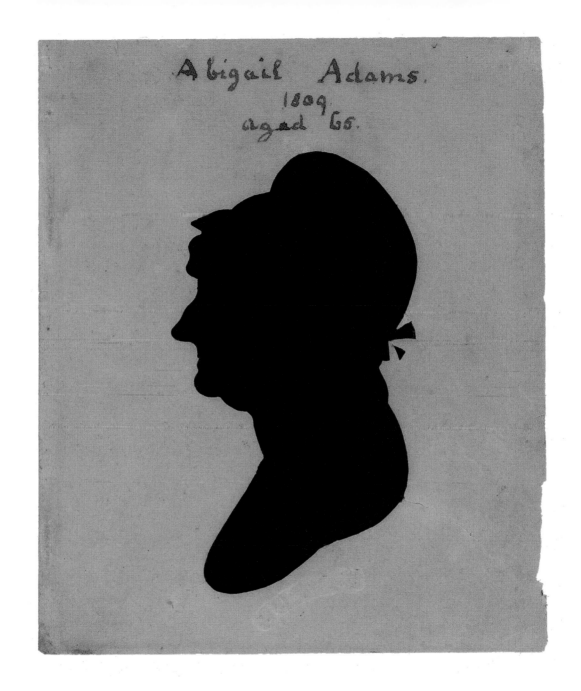

Abigail Adams.
1809.
aged 65.

MARTHA "PATSY" JEFFERSON RANDOLPH

The education of Martha "Patsy" Jefferson, in Philadelphia and Paris, was closely overseen by Thomas Jefferson, who doted on his eldest child. After she married in 1790, she continued to fervently support her widowed father, both at his Monticello home and in Washington, D.C. While her husband, Thomas Mann Randolph, was serving as governor of Virginia, Martha Randolph chose to live at Monticello. There, she kept house with the help of an extended family, which included her deceased mother's enslaved half-sister, Sally Hemings, and the illegitimate children that Hemings bore to Thomas Jefferson. (Randolph's half-siblings were also her cousins.)

Painter Thomas Sully was well acquainted with the Jefferson family, having spent two weeks at Monticello in 1821 making a portrait of the former president. When the artist painted this likeness of Randolph, she had outlived both her father and her husband. She appears in a black mourning dress; her serious face with its firm jaw is framed by jaunty curls and frills of imported lace.

Martha "Patsy" Jefferson Randolph (1772–1836)
Born Monticello, Virginia

Thomas Sully (1783–1872)
Oil on canvas, 29⅛ × 25⅛ in. (74 × 63.8 cm), 1836
Thomas Jefferson Foundation at Monticello

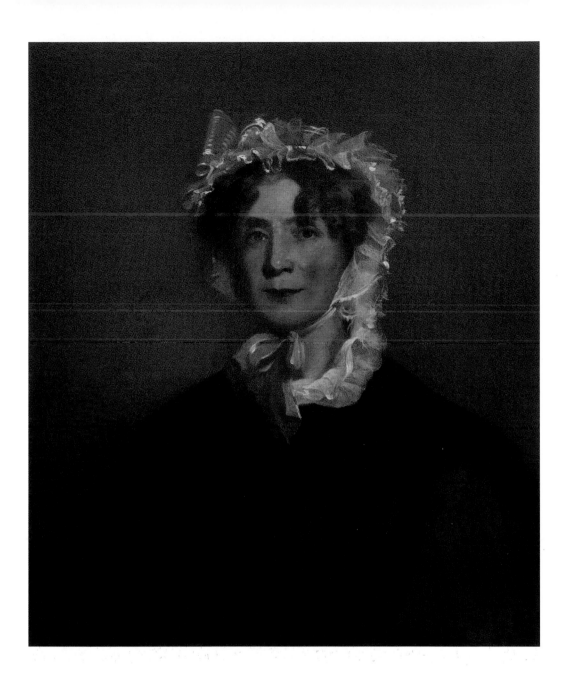

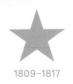

DOLLEY PAYNE TODD MADISON

Although raised by a Quaker family in Philadelphia, Dolley Payne Todd Madison quickly adapted to life at Montpelier, the large tobacco and wheat plantation in Virginia that was owned by her second husband, James Madison. Naturally vivacious and outgoing, she cultivated strategic friendships with both male politicians and their wives. Prior to her husband's presidency, she served as an honorary hostess for President Thomas Jefferson, which prepared her for the role that she took on when her husband entered the office. Madison's charisma and intelligence charmed the most hard-hearted politicians, making the lively Wednesday-night receptions she held at the White House the epicenter of Washington society. After the widower Martin Van Buren won the presidential election in 1836, Madison encouraged him to choose her relative and his daughter-in-law, Angelica Singleton Van Buren, as his hostess and first lady.

Madison's influence in Washington, D.C., was commemorated in 1844, when the House of Representatives voted unanimously to reserve a seat for her on the Congressional Floor to attend political debates. The following year, Sarah Polk entered the White House as first lady; the two of them soon formed a strong bond. Around this time, Dolley Madison experienced the dawn of photography, as the daguerreotype—the first popular form of the medium—entered into American culture.

Dolley Payne Todd Madison (1768–1849)
Born Guilford County, North Carolina

———

William S. Elwell (1810–1881)
Oil on canvas, 30¼ × 25¼ in. (76.8 × 64.1 cm), 1848
National Portrait Gallery, Smithsonian Institution
NPG.74.6

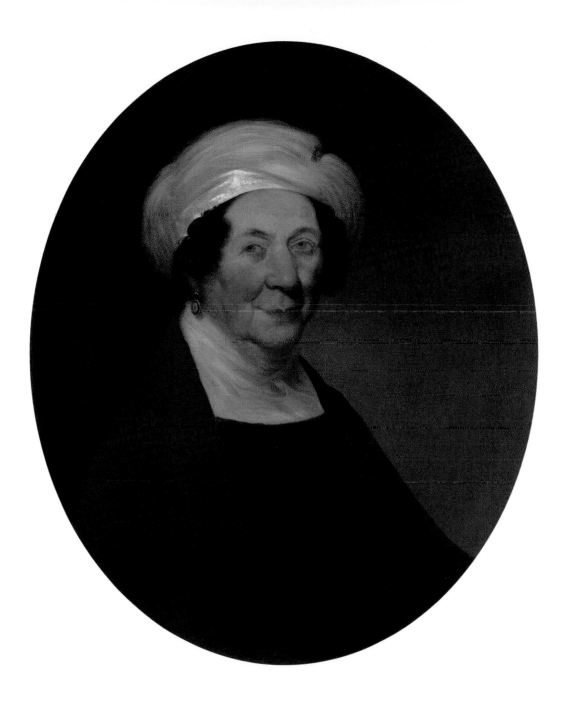

In 1848, about a year before her death, she and her niece visited the studio of Mathew Brady, who would later become famous for his Civil War–era photographs. Both the daguerreotype by Brady and a painted portrait by William Elwell of the same year offer insights into the aging Mrs. Madison, then eighty years old. Writing in his diary, Elwell described Madison as "a very Estimable lady—kind & obliging—one of the Old School."[40] He paid close attention to her blue eyes, which are a little cloudy, and her rouged cheeks. The black curls (hairpieces) that peek out from her signature turban hint at her interest in maintaining a hard-won and long-cultivated public persona.

Dolley Madison and Anna Payne

———————

Mathew B. Brady (c. 1823–1896)
Copy daguerreotype, 3⅜ × 2½ in. (8.5 × 6.3 cm), c. 1848
National Portrait Gallery, Smithsonian Institution;
gift of Dortha Louise Dobson Adem Rogus,
direct descendant of Dolley Madison
NPG.2006.92

ELIZABETH KORTRIGHT MONROE

Elizabeth Kortright Monroe was a remarkably cosmopolitan woman who spent two years in Paris while her husband, James Monroe, was serving as President George Washington's minister to France. During her time abroad, she established herself as a skilled hostess in the European style and also acquired diplomatic skills. At the height of the French Revolution's Reign of Terror, she visited the prison cell of Adrienne Lafayette, the marquis's wife, to save her from certain death at the guillotine. This distinguished act of bravery caused sympathetic Frenchmen to hail Elizabeth Monroe as "La Belle Américaine."[41]

During the couple's stay in Paris, they had the Swiss-French artist Louis Sené, known for his ivory miniatures, paint their portraits. The small size of these objects would have enabled James to carry Elizabeth's likeness in his pocket, while she might have worn his pinned to her dress or secured by a ribbon around her neck. In Sené's portrait of the future first lady, she appears as a fashionable young woman, with rosy cheeks and soft curls that are held back by a simple headband. The diaphanous white dress that she wears reflects the Greek revival style that characterized the optimism of the new French republic.

During her husband's presidential administration, Elizabeth Monroe formalized activities and implemented White House protocols that were adopted by successive first ladies. She also redecorated the White House using Parisian decor, giving the mansion a continental ambience.

Elizabeth Kortright Monroe (1768–1830)
Born New York, New York

———

Louis Sené (1747–1804)
Watercolor on ivory, approx. 3 × 3 in. (7.6 × 7.6 cm), c. 1795
Halton Family Collection; exhibited at James Monroe's Highland,
Charlottesville, Virginia

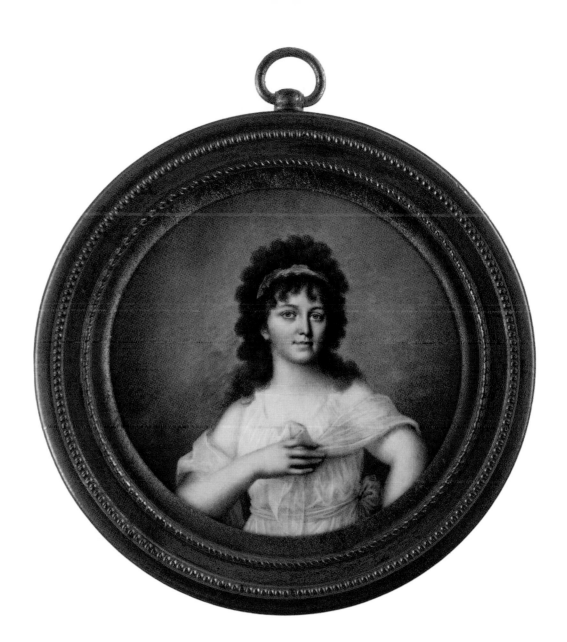

LOUISA CATHERINE JOHNSON ADAMS

Born in London, Louisa Catherine Johnson's extensive education and metropolitan upbringing began shaping her views on politics and society long before she married John Quincy Adams or entered the White House as his first lady. A talented musician, known for playing the harp, she was exceptionally charismatic and loved to entertain. Invitations to her parties were as sought after as those of Dolley Madison, who had set the bar high.

Adams's education at a convent school in France influenced her tactful approach to politics, and she went so far as to graciously host Andrew Jackson, one of her husband's most difficult political foes. A prolific writer, she used her position and political savvy to confront gender inequality in early American society, penning several autobiographical stories, notably *Adventures of a Nobody*, which she began writing around 1840.

This grand portrait, which captures the subject's continental sophistication, was painted by Charles Robert Leslie in London, one year after Adams had completed a harrowing six-week winter journey by sleigh from St. Petersburg to Paris. The headdress and empire waist evoke the five years that she spent at the court of Czar Alexander I while her husband served as President Madison's minister to Russia.

Louisa Catherine Johnson Adams (1775–1852)
Born London, United Kingdom

———

Charles Robert Leslie (1794–1859)
Oil on canvas, 36½ × 29 in. (92.7 × 73.7 cm), 1816
The Diplomatic Reception Rooms, U.S. Department of State, Washington, D.C.;
gift of Robert Homans Jr., Lucy Aldrich Homans, and Abigail Homans,
in memory of their father, Robert Homans

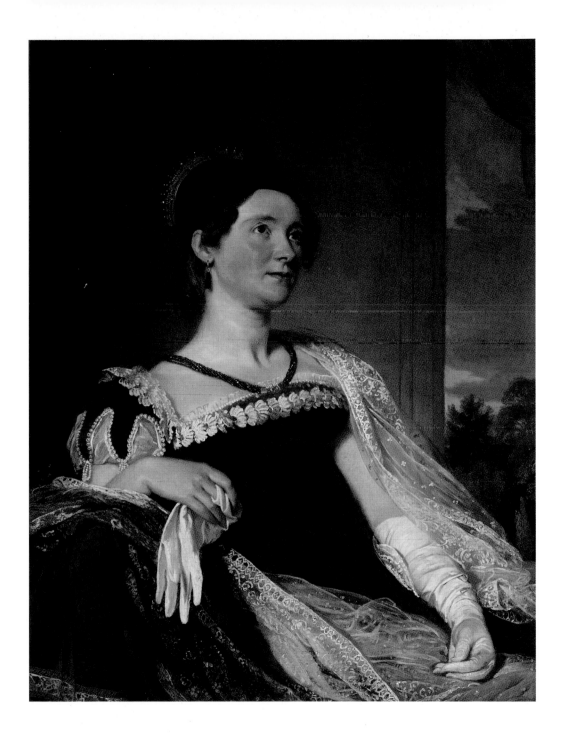

61

Made during the first two decades of the nineteenth century (before the advent of photography), this hollow-cut paper profile represents the period's most popular form of portraiture. Because of the limited visual information that can be gleaned from silhouettes, inscriptions, like the one atop this portrait, are often relied upon for sitter identification.

Louisa Catherine Johnson Adams

————

Henry Williams (1787–1830)
Hollow-cut silhouette, 4⅜ × 3⁹⁄₁₆ in. (11.1 × 9 cm), 1809
National Portrait Gallery, Smithsonian Institution
S/NPG.78.209

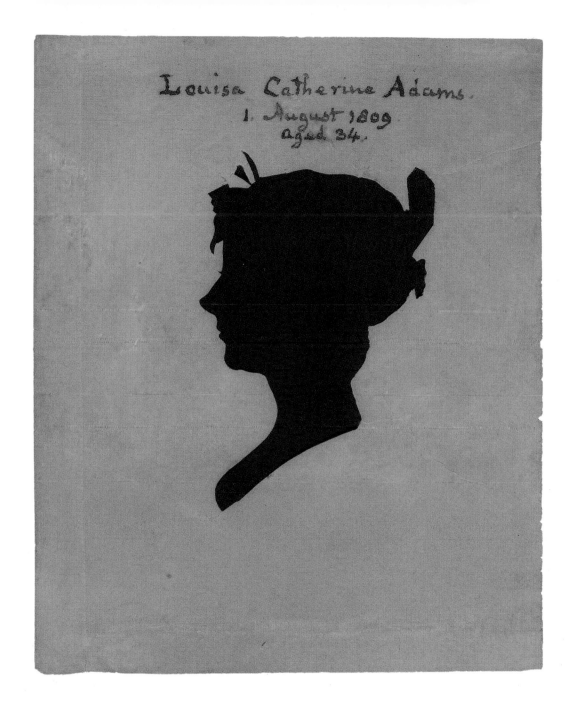

Louisa Catherine Adams.
1. August 1809.
aged 34.

Raised in Tennessee and Kentucky, Rachel Donelson was familiar with the challenges of frontier life when she married her first husband, Lewis Robards. She was not prepared, however, for his jealous rages in which "cruel taunts and upbraidings follow[ed] flattering endearments." They made life with him unbearable.[42]

In the early 1820s, long after securing a divorce from Robards and marrying Andrew Jackson, she encouraged her husband, then governor of Florida, to ban alcohol, as temperance advocates blamed it for fueling domestic violence. Later, she dedicated herself to managing the Hermitage, the Jacksons' large cotton plantation near Nashville.

This portrait of Rachel Jackson, by Ralph Eleaser Whiteside Earl, shows a serious, mature woman with a deeply lined brow. The small timepiece pinned to her collar would have been used to keep those who were enslaved at the Hermitage on a tight schedule. Although Jackson may have once been a beautiful young woman with "lustrous black eyes, dark glossy hair, full red lips, brunette complexion . . . [and] a sweet oval face rippling with smiles and dimples," here she only appears weary.[43] Rachel Jackson's health began to fail the year her husband was elected president, and before she died on December 22, 1828, her niece Emily Donelson agreed to serve as President Jackson's official hostess in the White House.

Rachel Donelson Robards Jackson (1767–1828)
Born Pittsylvania County, Virginia

———

Ralph Eleaser Whiteside Earl (c. 1788–1838)
Oil on canvas, 29 × 24 in. (73.7 × 60.9 cm), c. 1827
Andrew Jackson Foundation

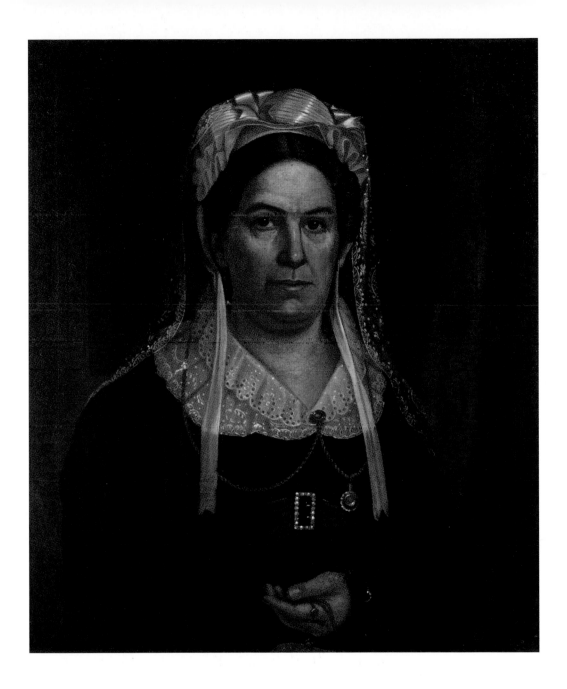

EMILY DONELSON

After her uncle Andrew Jackson's presidential inauguration, there was never any question that Emily Donelson would serve as White House hostess in place of her recently deceased Aunt Rachel. Emily's husband, Andrew Jackson Donelson, who was her first cousin and had been raised as a ward in the household of Andrew and Rachel Jackson, had long served as their uncle's personal secretary. The Donelsons lived first with their older relatives at the Hermitage, the Jacksons' vast plantation just outside of Nashville, Tennessee, and then moved to the White House after the inauguration, where three of their four children were born.

Once in Washington, Emily Donelson relished the positive attention that she received from the city's "cave dwellers," the name given to the hermetic upper echelon of Washington society who remained in place as the occupants of the White House changed. She quickly immersed herself in the capital city's social milieu and became one of its most admired hostesses.

The American artist Ralph Eleaser Whiteside Earl trained in London and Paris before returning to the United States and becoming the "court painter" to Andrew Jackson. Earl completed numerous portraits of members of the Jackson family, both before and after their move to Washington, D.C., and his ability to paint in radically different styles is made clear when one compares his portrait of Emily Donelson with that of Rachel Jackson (p. 65). The contrast in effect is particularly remarkable. Donelson's portrait appears softer and more romantic than her aunt's portrait, perhaps reflecting the contrast between Donelson's role as a young, gracious White House hostess and her aunt's role as the no-nonsense manager of a working plantation with over 100 enslaved people.

Emily Donelson (1807–1836)
Born Nashville, Tennessee

Ralph Eleaser Whiteside Earl (c. 1788–1838)
Oil on canvas, 30 × 25 in. (76.2 × 63.5 cm), c. 1830
Andrew Jackson Foundation

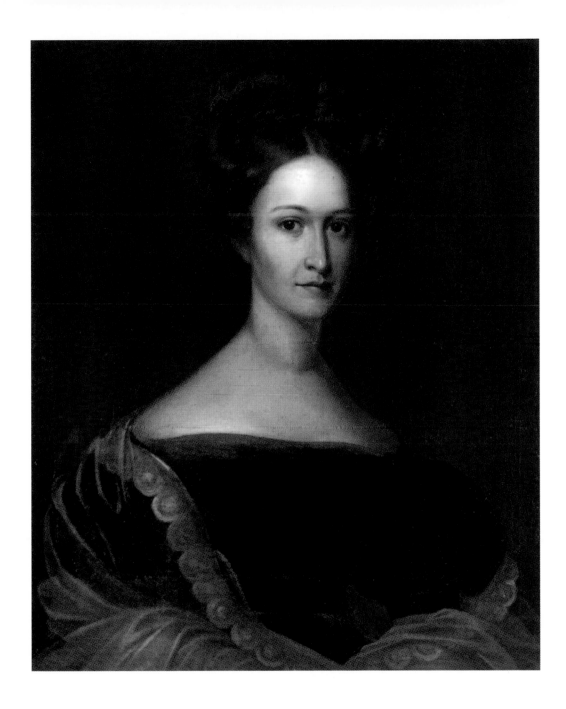

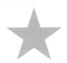

Born in Kinderhook, New York, and raised in a bilingual Dutch-American family, Hannah Hoes was married to her first cousin Martin Van Buren in 1807. While her husband was busy pursuing a political career in the state capital of Albany, she joined the local Presbyterian church and devoted herself to charitable work, which included supporting a school for the "unlettered waifs of the street."[44] Then in 1819, shortly before her thirty-sixth birthday, Van Buren contracted tuberculosis and died, leaving her husband to raise their five children. Inconsolable at the loss of his childhood sweetheart, Martin Van Buren never married again.

While the miniaturist who made this watercolor-on-ivory portrait of Hannah Van Buren paid close attention to the delicate details of her facial features and meticulously brushed in every bit of curling hair, the efforts made to gracefully accommodate a large lace ruff have resulted in giving the subject an exceptionally long neck. Her widowed husband probably carried this miniature portrait of his "Jannetje"—an affectionate Dutch diminutive form of the name Hannah—on his person for the rest of his life. Despite his devotion, or perhaps because of his profound grief, Martin Van Buren rarely spoke of his wife after she died. He did not even mention her in his autobiography. In fact, their four surviving sons grew up not knowing if their mother's name had been Hannah or Anna.

Hannah Hoes Van Buren (1783–1819)
Born Kinderhook, New York

Unidentified artist
Watercolor on ivory, 2⅜ × 2 1/16 in. (6 × 5.2 cm) framed, c. 1815
National Park Service, Martin Van Buren National Historic Site

SARAH ANGELICA SINGLETON VAN BUREN

Poised, confident, educated, and beautiful, Sarah Angelica Singleton grew up in South Carolina at Melrose House, one of three large plantations owned by her father. In 1838, she visited Washington, D.C., where her mother's cousin—the former First Lady Dolley Madison—introduced her to President Van Buren's eldest son, Abraham. The young couple married that November, when the bride was twenty, and two months later, on New Year's Day, Angelica Van Buren was installed as the youngest woman to serve as White House hostess.

Following her father-in-law's presidency, Angelica Van Buren settled with her family in New York City, where she kept busy with charity work. During the Civil War, in sympathy with her wealthy, slave-owning relatives in South Carolina and the other Southern secessionists, she sent blankets to Confederate soldiers who were being held in Northern prisons. In the years leading up to the war, the Singleton family had enslaved more than 500 people and held vast acreage in several South Carolina counties, so preserving that wealth—the source of her inheritance—would have been of great importance.

Charles Fenderich was a prominent Swiss-born portraitist and lithographer who was favored by many Washington, D.C., politicians and their families during the 1830s and 1840s. In this delicate watercolor, he pictures Angelica Van Buren in a fashionable dress with enormous leg-of-mutton sleeves. Some forgotten needlework rests in her lap as she gazes back at the visitors in this elegant sitting room.

Sarah Angelica Singleton Van Buren (1818–1877)
Born Wedgefield, South Carolina

———

Charles Fenderich (1805–1887)
Watercolor and graphite on paper, 16⁷⁄₁₆ × 13⁹⁄₁₆ in. (41.7 × 34.4 cm), c. 1838–41
Prints and Photographs Division, Library of Congress, Washington, D.C.

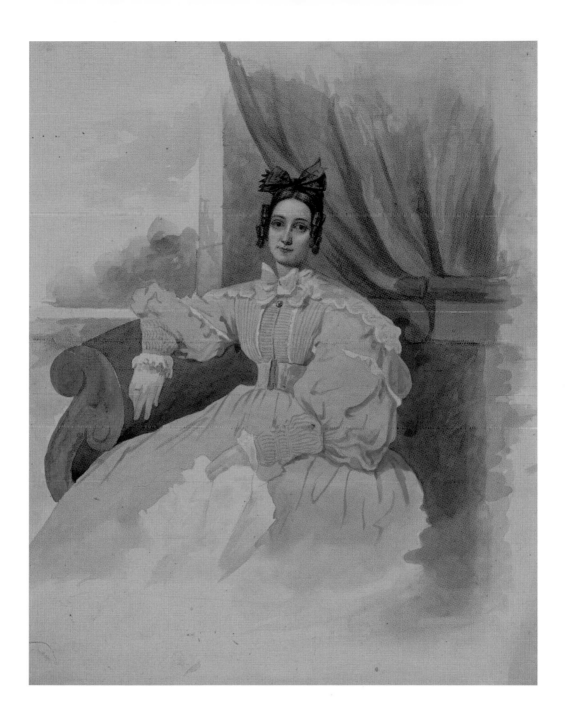

ANNA TUTHILL SYMMES HARRISON

In 1794, nineteen-year-old Anna Tuthill Symmes, along with her family, abandoned the comforts of the East Coast to resettle in the wilderness of Ohio, then part of the Northwest Territory. The following year, she met William Henry Harrison, who was serving as an Army officer attached to Fort Washington during the Northwest Indian War (1785–95). The young couple defied her father's wishes and married that November.[45]

The Harrisons had ten children, and such frequent childbearing left Anna Harrison in delicate health most of the time. Nevertheless, she endeavored to stay by her husband's side as much as possible. When he traveled to Washington for his presidential inauguration in March 1841, however, she stayed home to mourn the loss of a son, the sixth child of hers to die (three more would predecease her), and recuperate from an illness. Sadly, President Harrison became ill and passed away after just thirty days in office, and she was never able to join him in Washington, D.C.

This portrait shows Anna Harrison in a simple black mourning dress, alluding to a life that was marked by grief. Her hair is tied up beneath a spectacularly intricate lace cap, indicating that she was not in recent mourning; that would have required a black hair covering or veil.

Anna Tuthill Symmes Harrison (1775–1864)
Born Morristown, New Jersey

———

Unidentified artist
Oil on canvas, 30¼ × 25 in. (76.8 × 63.5 cm), c. 1820
The White House

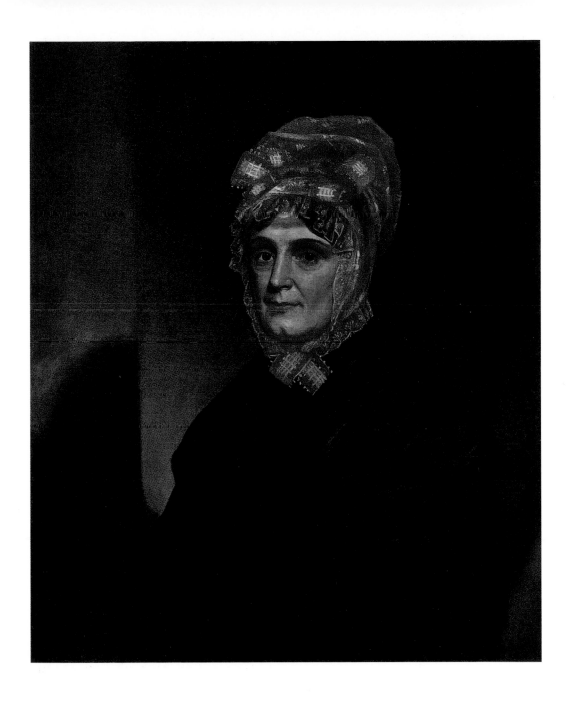

JANE FINDLAY IRWIN HARRISON WHITEMAN

Little is known about Pennsylvania-born Jane Findlay Irwin Harrison, who served as the official White House hostess for a very brief period in 1841. She had been living with her in-laws following the death of her husband, William Henry Harrison Jr., and when her mother-in-law was unable to attend William Harrison Sr.'s presidential inauguration, she and other family members accompanied the president-elect to Washington, D.C. During the month that the family occupied the White House, she received glowing reviews for the two receptions that she hosted. The term was cut short, however, when President Harrison died on April 4, 1841, after only a month in office.

With flowers placed at each ear and a veil pulled back from her face, this portrait of Jane Harrison was probably made to celebrate her second marriage, to widower Lewis Whiteman, following her return to North Bend, Ohio. Just a few years later, she succumbed to tuberculosis at age forty-two.

Jane Findlay Irwin Harrison Whiteman (1804–1847)
Born Mercersburg, Pennsylvania

Unidentified artist
Oil on canvas, 33 × 28 in. (83.8 × 71.1 cm) framed, c. 1841–42
National Museum of American History, Smithsonian Institution; gift of Barbara B. Rose

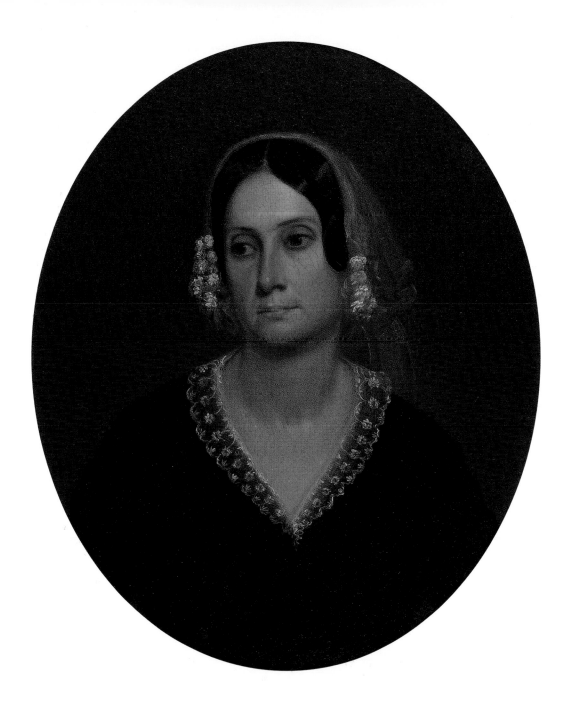

LETITIA CHRISTIAN TYLER

Letitia Christian Tyler spent most of her married life raising seven children and managing a busy plantation household to the east of Richmond, Virginia.[46] But her path drastically changed in 1839, after she suffered a stroke that left her partially paralyzed and having to use a "rolling chair." Two years later, her husband, Vice President John Tyler, unexpectedly became president after William Henry Harrison's sudden death. She moved into the White House in 1841, but because of her limited mobility, she spent most of her time in the mansion's second-floor private quarters while her daughter-in-law, Priscilla Cooper Tyler, assumed the hostess duties.

After a devasting second stroke in September 1842, Letitia Tyler became the first wife of a president to die in the White House. She was buried in the cemetery at Cedar Grove, the plantation in New Kent County, Virginia, where she had been born and where she had married John Tyler. Cedar Grove was also where she lived in the years leading up to her husband's election.[47]

Depicting Letitia Tyler in the bloom of youth, with an empire waist gown and fancy lace collar, this portrait is a copy that was made several decades after her death. The artist, Virginia native George Bagby Matthews, trained in Europe before setting up a studio in Richmond, where he specialized in duplicating older paintings and taking new commissions.

Letitia Christian Tyler (1790–1842)
Born Cedar Grove, Virginia

———

George Bagby Matthews (1857–1944)
Oil on canvas, 30½ × 26 in. (77.5 × 66 cm), 1885
National Museum of American History, Smithsonian Institution; gift of Letitia C. Arant

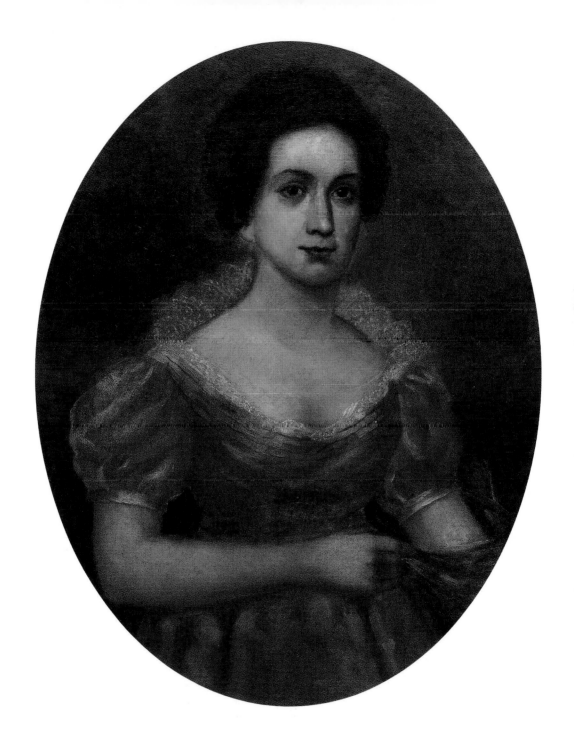

JULIA GARDINER TYLER

Julia Gardiner and the recently widowed President John Tyler fell in love when he comforted her following the tragic death of her father in an accidental explosion. After becoming the first woman to marry a president in office, she enjoyed just eight months holding court. The couple was separated by thirty years—he was fifty-four and she was twenty-four—but her youth and energy led to an active White House schedule. Enamored with European pageantry, she sought to elevate the presidency by having "Hail to the Chief" played on state occasions.

Raised in a wealthy slaveholding family on Long Island, Julia Tyler adapted easily to the Southern lifestyle of her Virginia-born husband.[48] This dazzling portrait, by Italian-born artist Francesco Anelli, was probably painted at Sherwood Forest, the Tylers' plantation on the James River in Virginia, which had been purchased following their wedding.

In 1853, Julia Tyler published an open letter defending slavery and describing the care that she claimed Southern ladies lavished on the African-descended people they enslaved. Later, she encouraged her sons to fight for the Confederacy.[49] Financially strapped after the war and her husband's death, Tyler unabashedly lobbied Congress for a presidential widow's pension, and it was granted in 1880.

Julia Gardiner Tyler (1820–1889)
Born Gardiner's Island, New York

———

Francesco Anelli (c. 1805–c. 1878)
Oil on canvas, 50⅛ × 38⅞ in. (127.3 × 98.7 cm), 1846–48
The White House

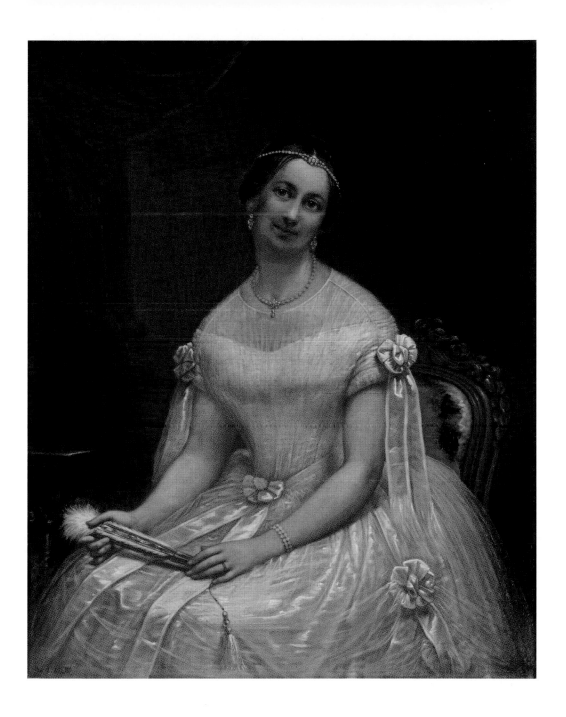

SARAH CHILDRESS POLK

Sarah Childress Polk made her husband James K. Polk's political career the main focus of her life. Up until he entered the White House, she served as his private secretary, handling his correspondence and scheduling his speaking engagements. She was his most trusted advisor, and because she believed that entertainment took away from business, she relied on White House staff to handle the bulk of the hostess duties. She spent these social occasions in conversation with politicians and concentrated on diplomacy and furthering legislation of importance to her husband's agenda. However, her greatest political maneuver took place after her husband's death when, during the Civil War, she was able to preserve Polk Place (the couple's Nashville home), where President Polk had been buried in the front yard, as neutral territory.

George Peter Alexander Healy's portrait of Sarah Polk shows her wearing a velvet evening gown made in a contemporary Parisian style. Her hair is covered by a matching velvet turban that is similar to the headdresses favored by her close friend and fellow first lady, Dolley Madison. This choice to emulate Madison's signature headwear speaks to the strong relationship between the two first ladies.

Healy, a native of Boston, moved to Paris in 1834, where he trained under top French painters and garnered prizes in the Salons. When he returned to the United States, he quickly became one of the most important antebellum portrait painters. Over the course of his career, which spanned more than sixty years, he painted ten sitting presidents but only one first lady—Sarah Polk.

Sarah Childress Polk (1803–1891)
Born Murfreesboro, Tennessee

———

George Peter Alexander Healy (1813–1894)
Oil on canvas, 30 × 25 in. (76.2 × 63.5 cm), 1846
President James K. Polk Home and Museum

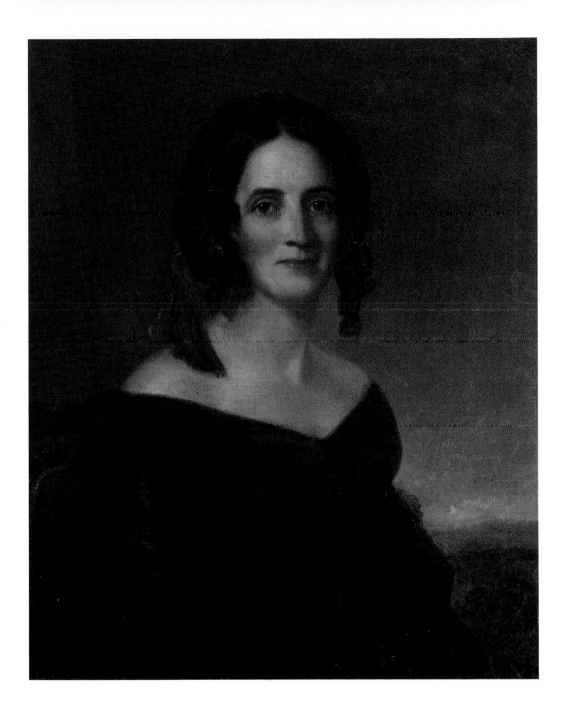

MARY ELIZABETH "BETTY" TAYLOR BLISS DANDRIDGE

Mary Elizabeth "Betty" Taylor Bliss Dandridge, the only surviving daughter of Zachary Taylor and Margaret Mackall Smith Taylor, was raised in frontier forts while her army general father conducted the Black Hawk War (1832) and the Second Seminole War (1835–42). Her mother, of whom no portraits or other accurate likenesses survive, worked hard to raise ten children while surrounded by soldiers.

After Betty Taylor married William Wallace Bliss, who was serving as her father's personal aide, the couple lived in the White House with her parents. During her father's presidency, Bliss became known for her sophistication and poise when acting as White House hostess, a duty her mother declined to assume. Though her time in the White House was a brief sixteen months, owing to her father's death in office, "Miss Betty" earned high public praise for her ability to lead conversations with men and balance her sense of humor with a common-sense attitude toward life. Following her husband William Bliss's death in 1858, she married Philip Dandridge, a great-grandnephew of Martha Washington.

Mary Elizabeth "Betty" Taylor Bliss Dandridge (1824–1909)
Born Fort Snelling, Minnesota

Unidentified photographer
Albumen silver print, 5⅛ × 4⅛ in. (13 × 10.5 cm) including mount, c. 1860
Winchester-Frederick County Historical Society, Winchester, Virginia

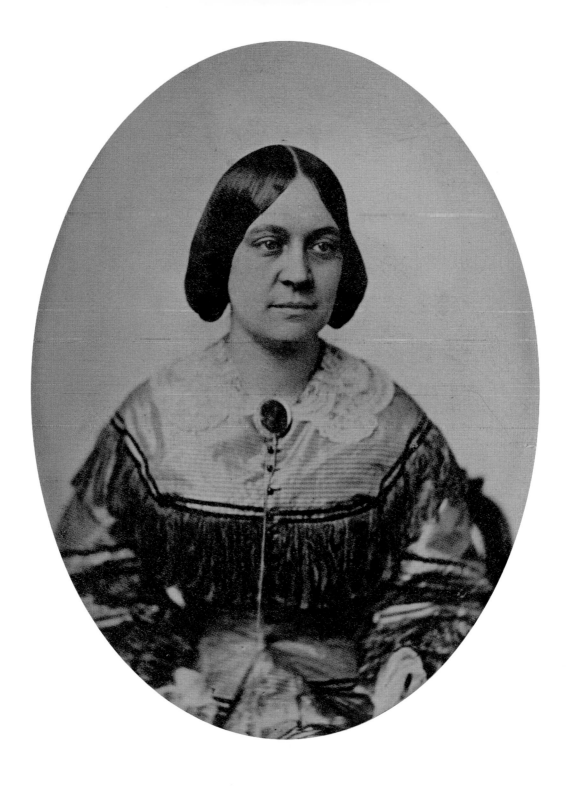

ABIGAIL POWERS FILLMORE

Unlike most of the wealthy, privileged first ladies who preceded her, Abigail Powers Fillmore came from hardscrabble beginnings. Her minister father died when she was a small child and left behind a singular, yet significant, possession: his library. Mr. Powers gifted his daughter his books, and she went on to devote her life to learning.

As a young schoolteacher, Abigail Powers fell in love with one of her students, nineteen-year-old Millard Fillmore, who was just learning how to read. The two bonded over their passion for knowledge. After their marriage, the bride made the unconventional decision to continue her teaching career as a way to support her husband's aspirations in law and politics. Years later, when Millard Fillmore assumed the presidency following the death of President Zachary Taylor in 1850, he and the new first lady established a reference library in the White House.

In this portrait, Abigail Fillmore's serious expression and piercing gaze are tempered by the delicate curls and floral hair decorations that frame her face. As first lady, she was especially curious about and culturally engaged with the world around her. The gold chain that hangs from her neck would have been attached to a watch to be used to keep up with her busy social schedule. She took immediate advantage of her new social position to establish an intermittent cultural salon in the White House. She frequently invited popular authors, including Charles Dickens and Washington Irving, and performers, such as Swedish soprano Jenny Lind and her manager, P. T. Barnum, to visit with her at the presidential mansion.

Abigail Powers Fillmore (1798–1853)
Born Stillwater, New York

Unidentified artist
Oil on canvas, 29^{15}/$_{16}$ × 25 in. (76 × 63.5 cm), c. 1840
National Portrait Gallery, Smithsonian Institution
S/NPG.78.20

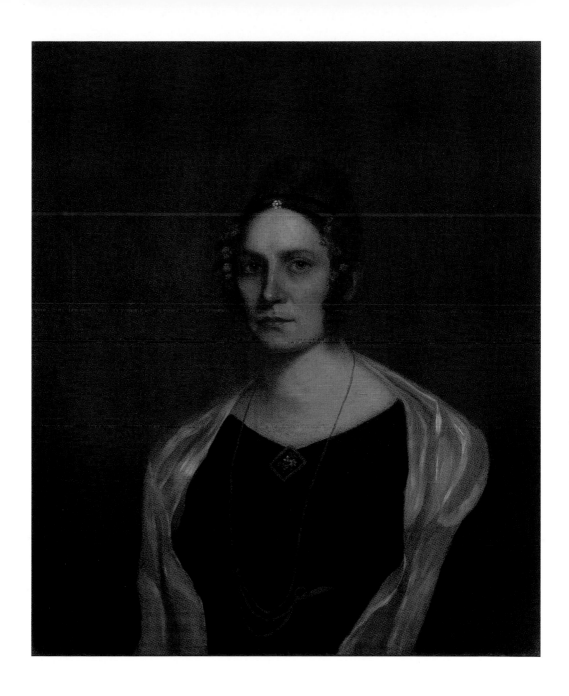

JANE MEANS APPLETON PIERCE

Jane Means Appleton Pierce had already experienced the death of two sons when her husband Franklin Pierce was elected president. Then, two months before his inauguration in 1853, their only surviving child, Benjamin ("Benny"), was killed before her eyes in a train accident. A daguerreotype portrait of Jane and Benny Pierce shows the bond the two shared (see fig. 7; p. 25). Rather than looking out at the camera operator as would be typical of most portraits of this era, the mother holds her son's hand as he gazes up into her serene face, one hand set reassuringly on her shoulder.

Jane Pierce never recovered from her loss, and when she finally joined her husband in Washington, D.C., some months after the inauguration, she struggled to meet the social expectations of being the first lady. Desperate to communicate with Benny, she had mediums hold a séance at the White House.

It took two years for Jane Pierce to assume White House hostessing duties, and in the meantime, she relied on her aunt, Abigail Kent Means, to organize events that she was unable to host. Her grief was so profound and visible that author Nathaniel Hawthorne described her as "that death's head in the White House."[50] Others, like Mary Custis Lee, the wife of Robert E. Lee, were more charitable. "I have known many of the ladies of the White House," Lee wrote a friend. "None more truly excellent than the afflicted wife of President Pierce; she was a refined, extremely religious and well-educated lady."[51]

Jane Means Appleton Pierce (1806–1863)
Born Hampton, New Hampshire

———

Unidentified photographer
Daguerreotype, 3½ × 3¼ in. (8.9 × 8.3 cm) including case, c. 1842–62
National First Ladies' Library

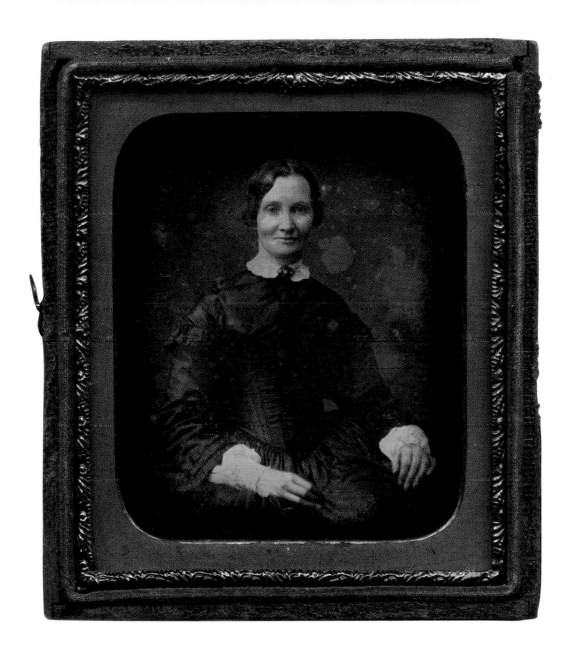

HARRIET REBECCA LANE JOHNSTON

Hailed as the "Democratic Queen," Harriet Rebecca Lane's charm and political savvy made her an excellent first lady for her bachelor uncle James Buchanan, who had looked after her following the death of her parents. She was an adept White House hostess who had become familiar with court life during three years spent hobnobbing with British royalty in London while her uncle served as the ambassador to the Court of St. James.

Lane was passionate about the visual arts, including Native American art, which led her to advocate for Native American welfare and the promotion of indigenous art. After her death, the gift of her vast painting and sculpture collection helped establish the holdings of what is now the Smithsonian American Art Museum.

Remarkably few portrait busts of women were made during the nineteenth century, so this marble portrait of Harriet Lane by William Henry Rinehart—made after Lane's marriage to Henry Elliott Johnston in 1866—is special. It highlights her bare shoulders above a deeply plunging neckline, a style she made fashionable when she altered her inauguration ball gown by lowering it two full inches. By depicting her in this way, Rinehart takes advantage of the luminosity of the marble and encourages us to imagine it as a corollary to the whiteness of her skin. During the mid-nineteenth century, upper-class women of European descent, such as Lane, were socialized to cultivate their whiteness by staying out of the sun and using cosmetics to artificially enhance the appearance of their skin.

Harriet Rebecca Lane Johnston (1830–1903)
Born Mercersburg, Pennsylvania

———

William Henry Rinehart (1825–1874)
Marble, 28 × 18⅞ × 12⅝ in. (71.1 × 47.9 × 32.1 cm), 1873
Smithsonian American Art Museum; bequest of Harriet Lane Johnston

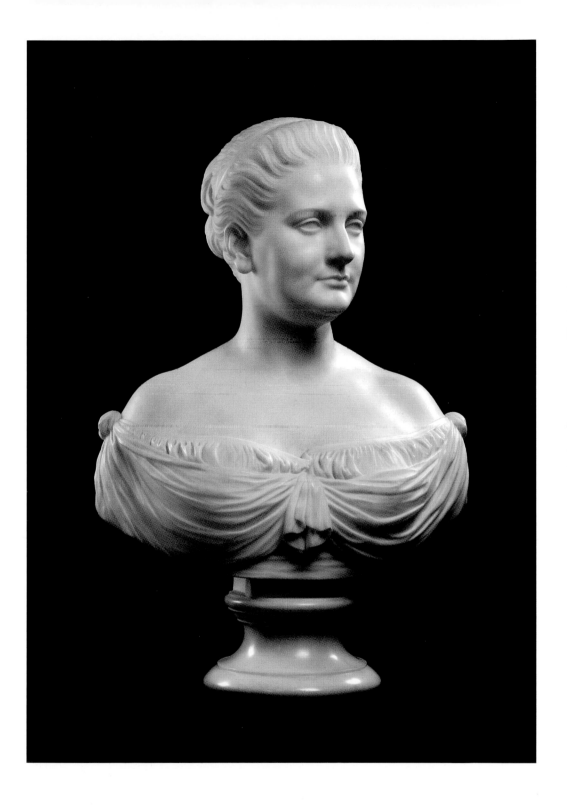

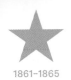

MARY ANN TODD LINCOLN

Raised in a wealthy Kentucky slave-owning family, Mary Ann Todd Lincoln actively voiced her political opinions throughout her life. But as a woman, she could not herself pursue office. These stifled ambitions may have led to her marital alliance with Abraham Lincoln, who was equally ambitious and in need of the kind of social polishing that her elite background could offer him.

Her focus on class position is evidenced in the many carte-de-visite photographs of her in fashionable costumes; these included black mourning clothes, which were an expensive luxury available only to the upper classes.

Nearly all of the clothing worn by Mary Lincoln after becoming first lady was sewn by Elizabeth Hobbs Keckley, the Virginia-born daughter of an enslaved woman and her white owner. An accomplished seamstress, Keckley at age thirty-seven was able to use her sewing skills to buy her freedom and that of her son from her own half-sister, who was then her owner. After moving to Washington, D.C., in 1860, Keckley became the preferred modiste, or dressmaker, to many important women in the capital, including Varina Davis, wife of then-Senator Jefferson Davis, and Mary Lincoln.

Mary Lincoln's obsession with clothing was highly criticized during the Civil War, and the press often overlooked the fact that she made frequent visits to hospitalized Union troops and housed soldiers at the White House. She also encouraged her husband to hire women in the treasury and war departments. After the war, Lincoln supported

Mary Ann Todd Lincoln (1818–1882)
Born Lexington, Kentucky

———

Mathew Brady Studio (active 1844–94)
Albumen silver print, 3⅜ × 2¹/₁₆ in. (8.6 × 5.3 cm), 1861
National Portrait Gallery, Smithsonian Institution
NPG.2005.112

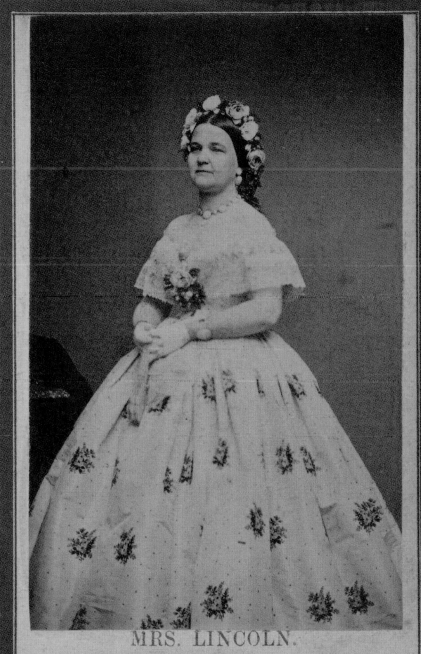

MRS. LINCOLN.

Entered according to Act of Congress in the year 1861, by M. B. Brady, in the
Clerk's office of the District Court of the U. S. for the So. District of New-York

the formerly enslaved by raising funds for Keckley's Contraband Relief Association, which aided the newly freed people who were flocking to Washington, D.C., in huge numbers in search of a new life.

Mary and Abraham Lincoln had three surviving sons when they arrived at the White House; their second child, Edward, had died in 1850, at age three. The oldest, Robert (standing, center), was a student at Harvard and was away from Washington, D.C., much of the time. "Willie" (seen in the framed picture) was a favorite of both parents and was remembered by a girl playmate as "the most lovable boy I ever knew, bright, sensible, sweet-tempered and gentle-mannered." He died of a "bilious fever" (probably typhoid) in 1862, causing enormous anguish for the first couple. The youngest son, Tad, was doted on by his parents, and was described by one of the president's secretaries as having "a very bad opinion of books and no opinion of discipline."

Lincoln and His Family

———

William Sartain (1843–1924), after Samuel Bell Waugh
Engraving, 21¹⁵⁄₁₆ × 28¼ in. (55.7 × 71.7 cm), 1866
National Portrait Gallery, Smithsonian Institution;
gift of Mr. and Mrs. Timothy J. Desmond
S/NPG.80.26

LINCOLN AND HIS FAMILY.

ELIZA McCARDLE JOHNSON

The daughter of a shoemaker, Eliza McCardle was sixteen when she married Andrew Johnson, a tailor. She worked with her husband by managing their small family shop in Greeneville, Tennessee, while he began to pursue a political career. When her husband was first elected to Congress in 1843, she "remained at home caring for the children and practicing economy" in Tennessee.[52]

After Abraham Lincoln's assassination and her husband's swearing-in as president, Eliza Johnson used a congressional appropriation of $30,000 to refurbish the White House interiors, which had become run-down during the Civil War. Because chronic tuberculosis limited her to the second floor of the mansion, she focused on running the household. Her oldest daughter, Martha Johnson Patterson, served as official White House hostess.

This hand-colored photograph of Eliza Johnson shows her later in life and emphasizes her conservative Methodist background. She wears a black silk crepe mourning dress with a white lace collar and a modest lace cap on her head. While it is difficult to make out the design of her oval brooch, it is likely that the chain or cord that hangs about her neck concludes in a pocket watch.

Eliza McCardle Johnson (1810–1876)
Born Telford, Tennessee

Unidentified photographer
Hand-colored photograph, 20¹⁄₁₆ × 16 in. (51 × 40.7 cm), c. 1865–76
Andrew Johnson National Historic Site

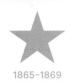

MARTHA JOHNSON PATTERSON

Martha Johnson Patterson joined her parents Andrew and Eliza Johnson in the White House, where she took on the responsibility of White House hostess. After the Lincoln assassination, the mansion had been left in tatters by souvenir seekers, and under the direction of her mother, Patterson helped to restore it to its former state. As a part of this work, Patterson chose to prominently display a series of portraits of recent former presidents, all of which had been painted by George Peter Alexander Healy. The subjects, both living and dead, included John Quincy Adams, Martin Van Buren, John Tyler, James K. Polk, Millard Fillmore, and Franklin Pierce. Commissioned by Congress in 1857, these portraits were part of the country's mid-nineteenth-century efforts to create a kind of political genealogy as the United States passed its seventy-fifth anniversary.

Martha Patterson's husband, David Trotter Patterson, was himself a member of Congress for three years, from 1866 until 1869, serving a single term as a US senator from Tennessee after it became the first Confederate state to be readmitted to the Union. During President Andrew Johnson's impeachment hearings, Senator Patterson's duties during the Senate trial made the process particularly difficult for the family. The couple believed the charges against her father to be false, but by the time the Senate vote fell short of the two-thirds needed to convict, both Pattersons had wearied of living in Washington, D.C.

Martha Johnson Patterson (1828–1901)
Born Greeneville, Tennessee

M. L. Barlow (life dates unknown)
Charcoal on paper, 27 × 22 in. (68.6 × 55.9 cm), 1886
Andrew Johnson National Historic Site

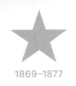

JULIA BOGGS DENT GRANT

For eight years, Julia Boggs Dent Grant reveled in her role as first lady and White House hostess, and following the couple's departure from the presidential mansion, she was loath to relinquish the spotlight. The White House receptions that she hosted were lavish affairs. At her husband's presidential inaugural ball, she wore diamond and pearl jewelry over a white silk dress trimmed with handmade lace. Grant also raised the expectations for entertaining by hosting foreign dignitaries, including King Kalākaua and Queen Kapiʻolani of the Sandwich Islands (Hawaiʻi), Russia's Grand Duke Alexis, and a delegation of Japanese political and military leaders. The state dinners she organized featured sophisticated menus prepared by Valentino Melah, the Italian-trained chef she hired, and often included as many as twenty-five courses.

Julia Boggs Dent Grant (1826–1902)
Born near St. Louis, Missouri

————

Mathew Brady Studio (active 1844–94)
Albumen silver print, 3⁵⁄₁₆ × 2¹⁄₁₆ in. (8.4 × 5.2 cm), c. 1864
National Portrait Gallery, Smithsonian Institution
S/NPG.79.246.156

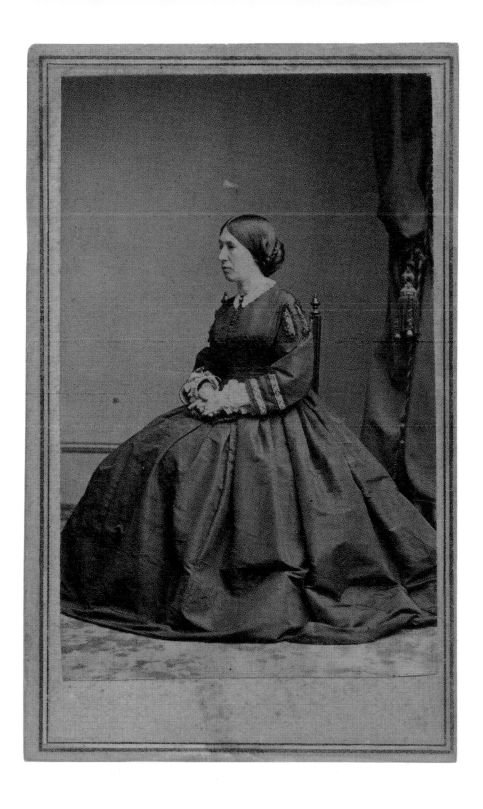

As this print made shortly after the Civil War demonstrates, Ulysses S. Grant, Julia Grant, and their children Fred, Buck, Nellie, and Jesse had achieved a remarkable level of fame before they even entered the White House. But some members of their household remained invisible. Raised on a farm outside of St. Louis, Missouri, that was worked by about thirty enslaved people, the new bride received a chilly welcome when she married into the staunchly abolitionist Grant family. A formerly enslaved woman who worked for the family later recalled that the general "wanted to give his wife's slaves their freedom as soon as he was able."[53]

Having been served by enslaved servants for most of her life, Julia Grant had only supervisory experience with cooking and baking. When as first lady she was asked to contribute to a charity cookbook, she submitted a friend's recipe for chicken gumbo.

General Grant and His Family

———

A. L. Weise & Co. (active 1865–c. 1912)
Hand-colored lithograph, 21⁵⁄₁₆ × 26⁷⁄₁₆ in. (54.1 × 67.2 cm), 1866
National Portrait Gallery, Smithsonian Institution
NPG.82.34

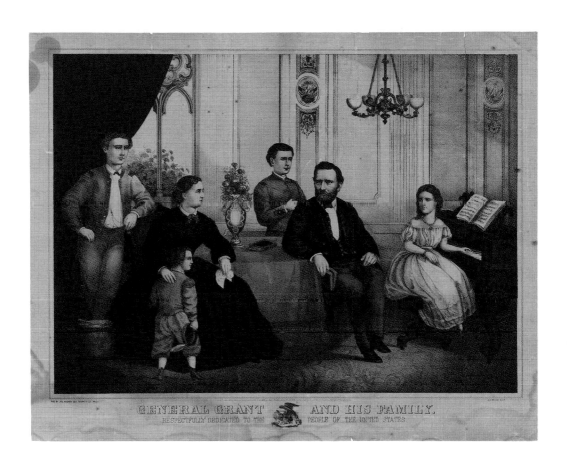

GENERAL GRANT AND HIS FAMILY.
RESPECTFULLY DEDICATED TO THE PEOPLE OF THE UNITED STATES

LUCY WARE WEBB HAYES

Lucy Ware Webb Hayes, who was the first presidential spouse to hold a college degree, graduated from Wesleyan Female College (now Ohio Wesleyan University) in 1850. That same year, she began a relationship with her future husband, the lawyer Rutherford B. Hayes. Having been raised in a Methodist family with abolitionist beliefs, she nursed Union soldiers at Hayes's camp during the Civil War, and after he became governor of Ohio in 1868, she accompanied him on public visits to prisons, schools, and hospitals.

As first lady, Lucy Hayes hosted the inaugural White House Easter Egg Roll and White House Thanksgiving Day celebration, both in 1878, and invited the mansion's secretaries and clerks to the latter. "There were placards for each and souvenirs for the children. The dinner was as elaborately served as the most ceremonious of state dinners," recalled a member of the staff.[54] She also expanded the White House's collection of presidential portraits and lobbied Congress to fund an official portrait of Martha Washington.

Lucy Hayes banned alcohol from White House events. In recognition of her dedication to the cause of sobriety, the Woman's Christian Temperance Union commissioned this grand portrait of Hayes by Daniel Huntington. The full-length format marks a shift in the representation of first ladies, while the outdoor setting alludes to the increasingly public nature of the role.

Lucy Ware Webb Hayes (1831–1889)
Born Chillicothe, Ohio

———

Daniel Huntington (1816–1906)
Oil on canvas, 87⅛ × 53¾ in. (221.3 × 136.5 cm), 1881
The White House

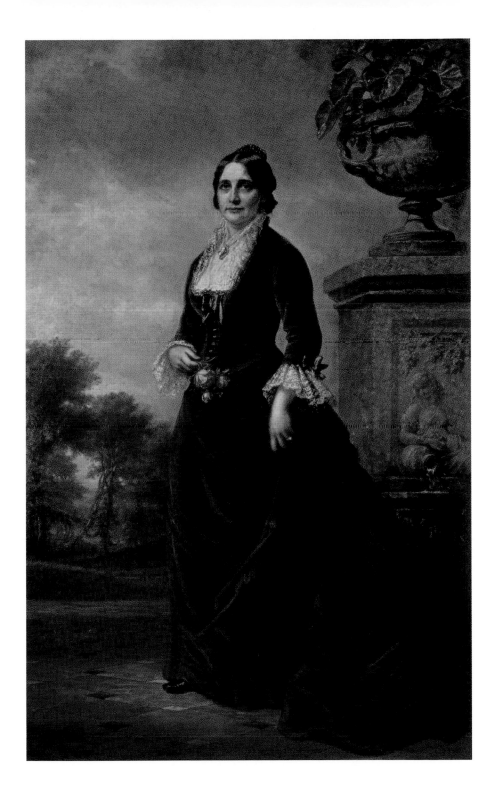

LUCRETIA RUDOLPH GARFIELD

The journalist Mary C. Ames once described Lucretia Rudolph Garfield as having a "philosophic mind" that made her not only her husband's equal "but in more than one respect his superior."[55] Lucretia Garfield loved literature and the classical world. She was fluent in French, German, Latin, and ancient Greek and spent much of her time in Washington, D.C., reading books that she borrowed from the Library of Congress. However, the demands of motherhood often stood in the way of her literary pursuits, and she once lamented that "the grinding misery of being a woman between the upper and nether millstone of household cares and training children" had come to dominate her life.[56]

This composite photograph, made from two separate negatives, hints at the physical and emotional distance that characterized the first couple's relationship. Lucretia and James Garfield lived apart during the early years of their marriage and exchanged over 1,200 letters during their twenty-three-year union.

On July 2, 1881, only a few months into his presidency, James Garfield was shot by Charles J. Guiteau, a failed lawyer who had been denied a political appointment. The first lady was still recovering from a bout with malaria but rose from her sickbed to nurse her husband. President Garfield died that September, and she dedicated the rest of her life to the preservation of his books and papers.

Lucretia Rudolph Garfield (1832–1918)
Born Garrettsville, Ohio

––––––––

James and Lucretia Garfield
Charles M. Litchfield (1850–1914)
Albumen silver print, 4 ¹¹⁄₁₆ × 3 ¹¹⁄₁₆ in. (11.9 × 9.4 cm), c. 1880
National Portrait Gallery, Smithsonian Institution; gift of George and Sue Whiteley
NPG.2017.133

Litchfield, 352 Washington St., Boston.

ELLEN "NELL" LEWIS HERNDON ARTHUR

The heiress Ellen Lewis Herndon brought great wealth to her 1859 marriage to Chester B. Arthur. In New York City, the couple kept a lavish Lexington Avenue townhouse, where she entertained guests and he indulged in Republican politics. During these years, "Nell," as she was known to family and friends, performed at high society gatherings as a featured soloist with the Mendelssohn Glee Club, the nation's oldest independent music group of its kind.

Less than a year before her husband was elected vice president of the United States, Ellen Arthur died of pneumonia in January 1880. Chester Arthur is said to have kept this photographic portrait of her at his bedside for the remainder of his life. When he was elevated to the presidency following the death of President Garfield in September 1881, he commissioned Louis Comfort Tiffany to create a stained-glass window of the Resurrection in memory of his wife. At the president's request, the window was installed at Saint John's Episcopal Church, across from the White House in Lafayette Square, so that he could see it illuminated at night from his private quarters.[57]

Ellen "Nell" Lewis Herndon Arthur (1837–1880)
Born Culpeper, Virginia

———

Charles Milton Bell (1848–1893)
Hand-tinted albumen silver print, 6¾ × 5⅜ in. (17.1 × 13.7 cm) framed, 1870–80
Prints and Photographs Division, Library of Congress, Washington, D.C.

MARY ARTHUR MCELROY

The recently widowed Chester Arthur asked his sister, Mary Arthur McElroy, to serve as his official hostess when he became president in 1881. McElroy continued to live with her family in Albany, New York, but she spent each winter social season (from mid-November to the beginning of Lent) in Washington, D.C. In general, she kept a reduced social schedule because the nation was mourning President Garfield, and her brother was grieving over the loss of his wife. McElroy's young niece Ellen, affectionately called "Nellie" after her late mother, often assisted her. In acknowledgement of her role as hostess but not spouse, McElroy was referred to as "Mistress of the White House."

McElroy was extremely active in civic life. Despite her exposure to and participation in local and national politics, she strongly believed that women should not have the right to vote. To that end, she took on a leading role in the Albany branch of the New York State Association Opposed to Woman Suffrage.

This elegant engraving, created when McElroy's time in the White House was drawing to a close, served as the basis for a portrait in the 1903 volume *Presiding Ladies of the White House*. The accompanying biographical text notes that McElroy's "residence at the White House was . . . marked by graceful and dignified hospitality."[58]

Mary Arthur McElroy (1841–1917)
Born Greenwich, New York

———

John Sartain (1808–1897)
Engraving, 5½ × 4½ in. (14 × 11.4 cm), c. 1885
The White House

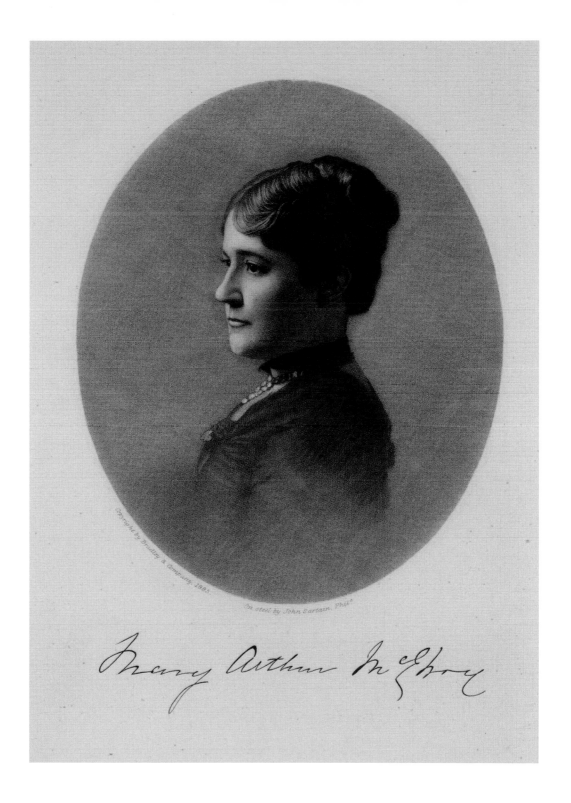

Copyright by Bradley & Company, 1901.

On steel by John Sartain, Phil.

Mary Arthur McElroy

ROSE ELIZABETH "LIBBY" CLEVELAND

When bachelor Grover Cleveland assumed the presidency for the first time in 1885, he asked his unmarried sister, Rose Elizabeth "Libby" Cleveland, to serve as White House hostess. The job of first lady was tedious for Cleveland, who was a highly successful and accomplished literary scholar. After her brother's marriage to Frances Folsom, she chose to pursue her writing. Cleveland's first novel, *The Long Run*, was published in 1886, and she briefly served as editor for the scholarly magazine *Literary Life*.

In the winter of 1889–90, Rose Cleveland began a relationship with Evangeline Marrs Simpson, a wealthy married woman who eventually became her life partner. Evangeline's second husband, Bishop Henry Whipple, died in 1901, and by 1910, the two women were living in Italy together. They made a home in the village of Bagni di Lucca, in the Tuscany region, and remained together until November 1918, when Rose Cleveland succumbed to the Spanish flu. Today, one can visit the couple's matching gravestones in Bagni di Lucca, where they are buried side by side. Their love letters, which are housed in the Whipple collection of the Minnesota Historical Society, were published in 2019.[59]

This portrait of Rose Cleveland was made by John Chester Buttre, one of the leading portrait engravers of his generation. Throughout the last quarter of the nineteenth century, Buttre produced elegant stipple and line engravings in honor of several first ladies, including Martha Washington, Harriet Lane Johnston, and Lucretia Garfield.

Rose Elizabeth "Libby" Cleveland (1846–1918)
Born Buffalo, New York

———

John Chester Buttre (1821–1893)
Engraving, 4¹³⁄₁₆ × 4⁵⁄₁₆ in. (12.3 × 11 cm), 1885
National Portrait Gallery, Smithsonian Institution
NPG.2019.168

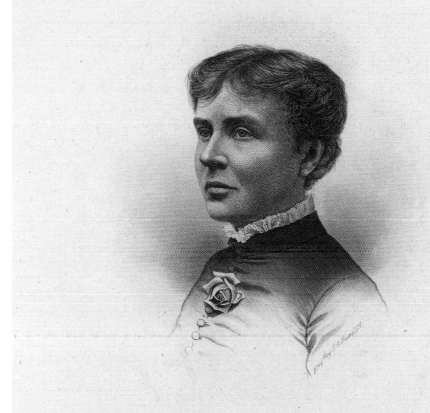

Rose Elizabeth Cleveland

FRANCES FOLSOM CLEVELAND PRESTON

No other first lady had been a celebrity before Frances Folsom Cleveland. Her marriage to President Grover Cleveland in 1886 drew extensive media attention. Called "Frank" as a baby (and later "Frances"), she had known Grover Cleveland since her birth; almost three decades her senior, he had been her father's law partner and served as the executor of her father's vast estate upon his early death. At twenty-one, Frances Folsom became the youngest first lady when she married President Cleveland, and when he was re-elected to an unprecedented non-consecutive second term in 1892, she became the only woman to serve as first lady twice.

This elegant portrait of Frances Cleveland by Swedish artist Anders Zorn acts as a companion to Zorn's likeness of Grover Cleveland, which is also in the National Portrait Gallery's collection. The painting shows the former first lady at age thirty-five, at the couple's home in Princeton, New Jersey. She wears one of her signature looks: a lace-ruffled gown revealing her bare shoulders and arms.

Unofficial portraits of Frances Cleveland circulated widely, in the form of advertisements and commemorative souvenirs (see fig. 12; p. 36). She was so admired that during the 1880s, women formed "Frankie Clubs" in an effort to garner votes for her husband.

Frances Folsom Cleveland (1864–1947)
Born Buffalo, New York

———

Anders Zorn (1860–1920)
Oil on canvas, 54⅞₁₆ × 36¹¹⁄₁₆ in. (138.3 × 93.2 cm), 1899
National Portrait Gallery, Smithsonian Institution; gift of Frances Payne
S/NPG.77.124

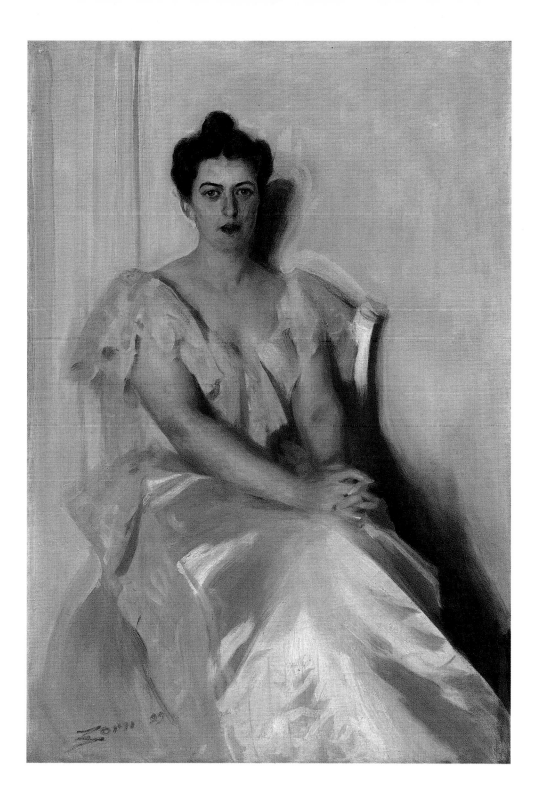

Frances Folsom Cleveland

Charles Milton Bell (1848–1893)
Albumen silver print, 4¾ × 3⁹⁄₁₆ in. (12 × 9 cm), 1886
National Portrait Gallery, Smithsonian Institution; gift of Francis A. DiMauro
NPG.2007.292

Frances Folsom Cleveland

Frances Benjamin Johnston (1864–1952)
Gelatin silver print, 7¹¹⁄₁₆ × 5½ in. (19.5 × 14 cm), c. 1897
National Portrait Gallery, Smithsonian Institution
S/NPG.77.57

CAROLINE LAVINIA SCOTT HARRISON

Caroline Lavinia Scott held a degree in music and taught at the college level before marrying Benjamin Henry Harrison, the grandson of President William Henry Harrison, in 1853. Raised in a resolutely anti-slavery household, Harrison participated in the Ladies' Sanitary Committee, which helped to care for wounded Union soldiers during the Civil War. In the White House, she established the presidential china collection and initiated a mass restoration of the presidential mansion that included installing electricity.

In 1890, Harrison was a founder of the Society of the Daughters of the American Revolution and served as its inaugural president general. In that role, she became the first wife of a sitting president to make a public speech. Before her untimely death, she helped raise money for the establishment of the Johns Hopkins University School of Medicine on the condition that they admit women students to their degree programs.

Caroline Harrison posed for this photograph shortly before she became first lady. Taken in Indianapolis, Indiana, where the Harrison family had made their home, the photographer (likely D. R. Clark) positioned Harrison in profile, highlighting her curled bangs and knotted bun. In the nineteenth century, such hairstyles required extensive maintenance and resources. Thus, the thickness and length of Harrison's tresses would have been read as signs of her good health and modern hygiene practices, qualities that would have elicited great admiration.

Caroline Lavinia Scott Harrison (1832–1892)
Born Oxford, Ohio

———

[D. R.] Clark (active 1880s and 1890s)
Albumen silver print, 5 7/16 × 3 7/8 in. (13.8 × 9.9 cm), c. 1889
National Portrait Gallery, Smithsonian Institution; gift of Francis A. DiMauro
NPG.2007.293

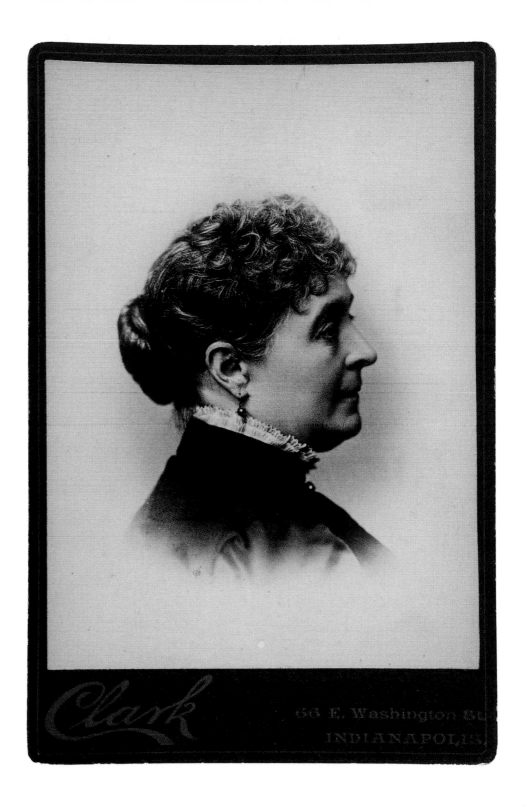

Clark 66 E. Washington St. INDIANAPOLIS

IDA SAXTON McKINLEY

Ida Saxton worked in Canton, Ohio, as a teller and manager in her father's bank before her marriage to William McKinley in 1871. Following the deaths of their two young daughters, Katie and Ida, within two years of each other in the mid-1870s, her health deteriorated radically as she grappled with depression and seizures. When Ida Saxton McKinley became first lady in 1897, she was often too weak to stand for the long periods of time that her position required. Hosting duties were, therefore, often assumed by Second Lady Jennie Tuttle Hobart, wife of Vice President Garret Hobart. Ida McKinley nevertheless attended most formal dinners at the White House, where she was routinely seated next to her husband (rather than at the opposite end of the table) so that he could cover her face with a handkerchief if she experienced a seizure. This portrait miniature, painted when the McKinleys were in the White House, highlights the first lady's cropped hair; doctors had recommended that she keep her hair short to lessen the weight on her cranial nerves.

While attending the Pan-American Exposition in Buffalo, New York, in 1901, President McKinley was assassinated by Leon Czolgosz, an avowed anarchist. In the eyes of a shocked nation, the first lady showed remarkable strength, but her grief was compounded by the recent loss of her brother, who had been killed by his lover. During the remaining six years of her life, Ida McKinley visited her husband's grave almost daily.

Ida Saxton McKinley (1847–1907)
Born Canton, Ohio

———

Emily Drayton Taylor (1860–1952)
Watercolor on ivory, 3³⁄₁₆ × 2½ in. (8.1 × 6.4 cm), 1899
The White House

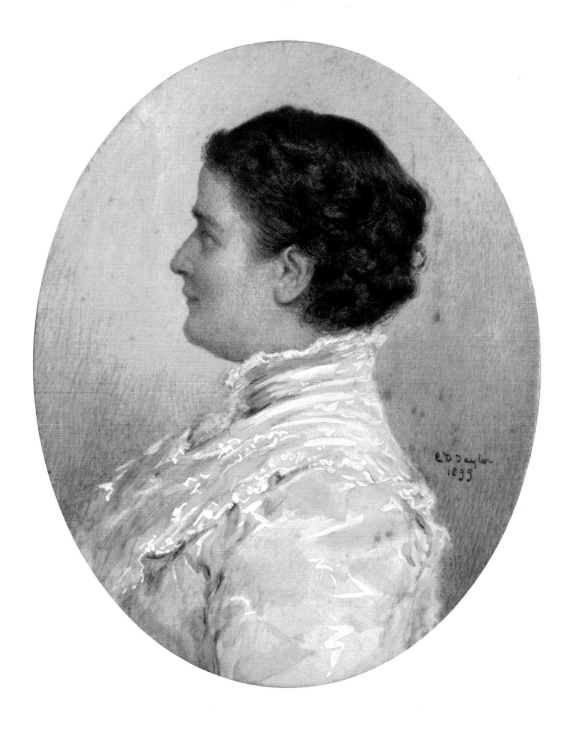

EDITH KERMIT CAROW ROOSEVELT

Edith Kermit Carow and Theodore Roosevelt were romantically involved as teenagers, but they did not marry until later. The couple renewed their relationship after Theodore's first wife, Alice Lee Roosevelt, died of Bright's disease following childbirth. Having lost his mother on the same day, February 14, 1884, he wrote in his diary, "X / The light has gone out in my life." Two years afterward, Edith and Theodore Roosevelt married in London.

Following William McKinley's assassination in 1901 and her husband's elevation to the presidency, Edith Roosevelt focused on raising her stepdaughter, Alice, and the couple's five rambunctious children while modernizing the role of first lady. She broke tradition and hired a social secretary. In addition, she appointed a chief usher; oversaw a major renovation and expansion of the White House; and established the East Wing, creating a suite of offices for the first lady.

Cecilia Beaux, who painted this double portrait of Edith Roosevelt and her daughter Ethel, was one of the most prominent society portraitists of her generation, having trained at the Pennsylvania Academy of the Fine Arts in Philadelphia and at the Académie Julian in Paris. Many years after the portrait was made, Isabella Hagner, the first White House social secretary, recalled, "Ethel now has [the portrait] hanging in her drawing room at Oyster Bay. In the picture she was sitting beside her mother. Her figure is almost like a sketch, while Mrs. Roosevelt's is a finished portrait."[60]

Edith Kermit Carow Roosevelt (1861–1948)
Born Norwich, Connecticut

———

Edith and Ethel Roosevelt
Cecilia Beaux (1855–1942)
Oil on canvas, 44 × 32 in. (111.8 × 81.3 cm), 1902
Collection of Sarah Chapman

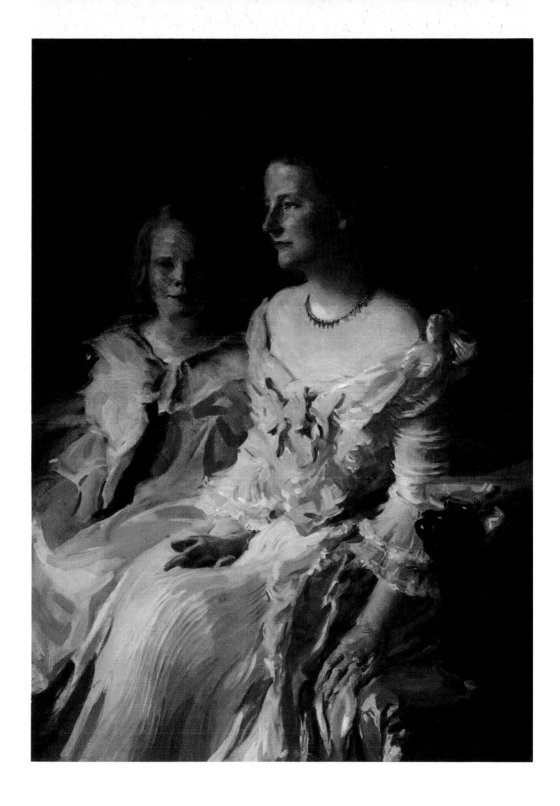

HELEN "NELLIE" LOUISE HERRON TAFT

Helen "Nellie" Louise Herron Taft wanted nothing less than for her husband, William Howard Taft, to become president of the United States. In 1900, she encouraged him to accept President William McKinley's appointment as chief administrator of the Philippines because she thought it would help him achieve this goal. The United States had coercively purchased the colonial island chain from Spain, and William Taft was tasked with establishing a civil government and running the country. When her husband was elected to the US presidency several years later, Helen Taft wrote that she felt a "secret elation" while riding with him in the 1909 inaugural parade, something no first lady had done before.[61] However, her most important legacy might be the 3,020 Japanese cherry trees that she had planted on the grounds of the Capitol and along the Tidal Basin in Washington, D.C. Having become enamored with their blossoms while visiting Japan in 1900, she rightly believed they would add great beauty to the nation's capital.

This drawing of Helen Taft was probably made around 1912 for a volume by Scribner, the venerated publishing house. Based upon a photograph by Harris & Ewing, Washington, D.C.'s premiere photography studio, it shows her in evening wear, with a diamond tiara atop her head and a pearl choker clasped around her neck. In her final act as first lady, the glamorous Taft donated her inauguration gown to the Smithsonian Institution, marking the beginning of the First Ladies' gown collection.

Helen "Nellie" Louise Herron Taft (1861–1943)
Born Cincinnati, Ohio

———

Jacques Reich (1852–1923)
Ink on paper, 7⁵⁄₁₆ × 5 in. (18.5 × 12.7 cm), c. 1912
National Portrait Gallery, Smithsonian Institution
S/NPG.72.68

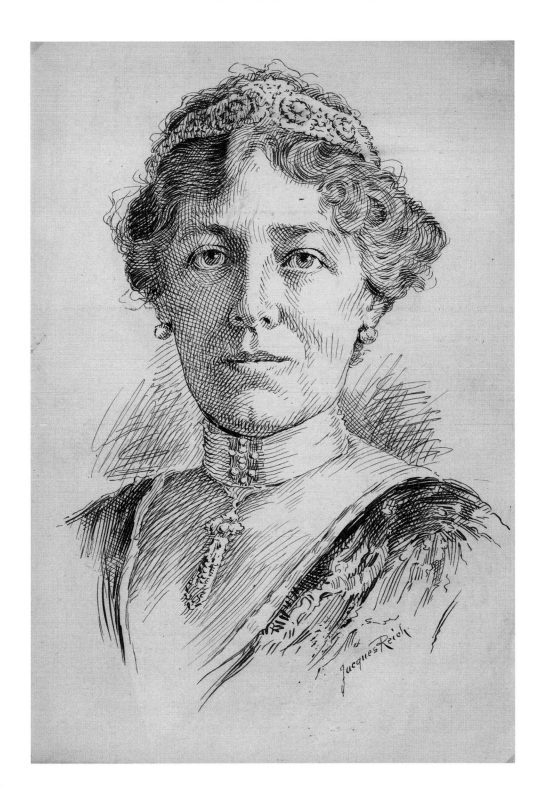

ELLEN LOUISE AXSON WILSON

During her short time as first lady, Ellen Louise Axson Wilson used her position of influence to promote social welfare initiatives. She campaigned for women's restrooms in civic buildings and supported child welfare laws. Despite her husband Woodrow Wilson's efforts as president to segregate federal workplaces and institute Jim Crow laws throughout the country, she actively lobbied Congress for passage of the Alley Dwelling Bill, an effort to improve the living conditions of poor Black residents in the nation's capital. Later, White House seamstress and memoirist Lillian Rogers Parks recalled that the mostly African American domestic staff recognized Wilson's efforts by calling her "The Lady" and "The Great and Good Lady."[62]

After President Wilson's inauguration in 1913, the Wilson family spent the summer at an artist's colony in Cornish, New Hampshire. Between breaks from her own painting practice, which focused on landscapes, Ellen Wilson posed for this painting with her three daughters, Margaret, Eleanor, and Jesse (*left to right*). The artist, American impressionist Robert Vonnoh, was married to renowned sculptor Bessie Potter Vonnoh and was a family friend. Painted in shades of blue and green, the portrait shows the four women arranged around a table taking their afternoon tea. The aquatic colors of their elegant dresses rhyme with the reflecting pool and verdant garden that frame their gathering. Ellen Wilson died the following year, in 1914, of Bright's disease.

Ellen Louise Axson Wilson (1860–1914)
Born Savannah, Georgia

———

Ellen Axson Wilson with Daughters
Robert Vonnoh (1858–1933)
Oil on canvas, 45½ × 45½ in. (115.6 × 115.6 cm), 1913
President Woodrow Wilson House, A Site of the National Trust for Historic Preservation

EDITH BOLLING GALT WILSON

President Woodrow Wilson had been devoted to his first wife, Ellen Axson Wilson, so when she died of Bright's disease during his second year in office, few imagined that he would be remarried within a year. The grieving president met Edith Bolling Galt through his cousin Helen Woodrow Bones, and the two quickly fell in love. After her first husband, Norman Galt, died in 1908, Edith had taken over the management of his jewelry store. A successful and remarkably independent businesswoman, she drove around Washington, D.C., in an electric car. She brought great energy to their union and an innovative spirit to the White House. As first lady during World War I, when gardeners were in short supply, she used sheep to maintain the White House lawn and donated their wool to the war effort. Despite her aversion to suffragists, who began picketing outside the White House in 1917, in 1920, she became the first wife of a sitting president to cast a vote in a US election.

This elegant portrait of Edith Wilson was probably begun in 1923 and finished before Woodrow Wilson's death in February 1924. If it had been made later, painter Emile Alexay certainly would not have chosen to represent the former first lady in a white silk evening gown. Having studied art in Budapest and Munich, Alexay painted members of the Hapsburg dynasty before immigrating to the United States in 1920. Here, the artist synthesizes idealism and naturalism, representing his subject as both dreamily feminine and honestly middle-aged.

Edith Bolling Galt Wilson (1872–1961)
Born Wytheville, Virginia

———

Emile Alexay (1891–1949)
Oil on canvas, 46¼ × 31⁵/₁₆ in. (117.5 × 79.5 cm), 1924
National Portrait Gallery, Smithsonian Institution; gift of Dr. Alan Urdang
NPG.69.43

FLORENCE MABEL KLING DeWOLFE HARDING

In 1891, Florence Mabel Kling was a divorcée and single mother who was supporting herself as a piano teacher when she married Warren Harding, a newspaper publisher five years her junior. She helped him run the *Marion Star* for fourteen years and later assisted with his political campaigns, beginning with his run for the Ohio state senate in 1898. During his presidential campaign, she led the press to believe that she had been a widow when she married her husband. She also refused to let his campaign issue a statement in response to public speculation that he had African American ancestors. In addition to being media savvy, Florence Harding was an advocate for women's suffrage, and after the ratification of the Nineteenth Amendment in 1920, she became the first woman to vote for her husband to become president.

As first lady, Florence Harding used her public platform to champion women's education and professional advancement. This photograph shows her in the uniform of the Girl Scouts of America, an organization she strongly supported. From the South Portico of the White House, she and Laddie Boy, the "first dog," stare purposefully into the distance. The Airedale terrier had been a gift to the president and first lady and quickly became the first White House celebrity pet. In fact, both Florence Harding and Laddie Boy had their own chairs to sit in during cabinet meetings. After President Harding's death in office, the Roosevelt Newsboys' Association commissioned a sculpture of Laddie Boy as a memorial to him. It is now in the collection of the Smithsonian Institution.

Florence Mabel Kling DeWolfe Harding (1860–1924)
Born Marion, Ohio

———

Florence Harding with Laddie Boy
Edmonston Studio (active 1912–45)
Gelatin silver print, 18⅝ × 14⅞ in. (47.3 × 37.8 cm), c. 1921–23
National First Ladies' Library

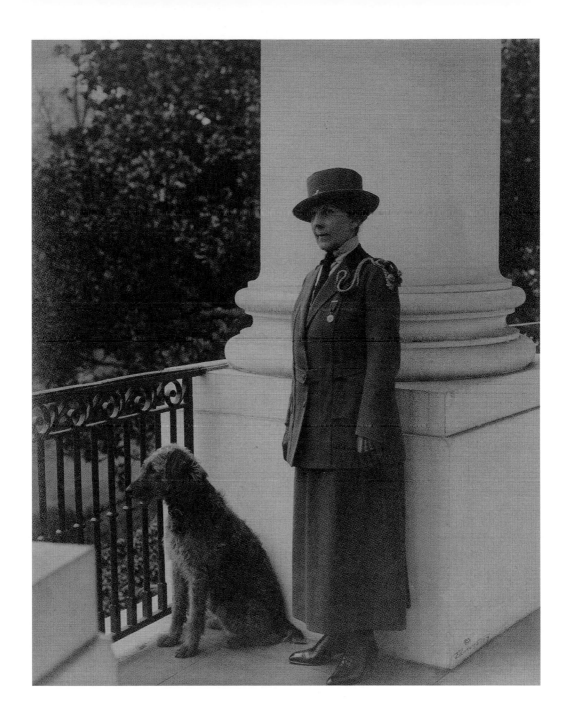

GRACE ANNA GOODHUE COOLIDGE

Grace Anna Goodhue Coolidge was as friendly and outgoing as her husband Calvin Coolidge was stoic and reclusive, and her accessibility was central to his popular appeal. Before marriage, she taught lipreading to students at the Clarke School for the Deaf in Northampton, Massachusetts; she remained deeply involved with that institution until the end of her life. After Warren Harding suffered a heart attack in 1923 and her husband, the vice president, was sworn into office, Coolidge rapidly adjusted to the duties of being the first lady and became one of the most photographed women of the 1920s. Always a bit of a maverick, when she was presented with a raccoon as a gift for Thanksgiving dinner, she named it "Rebecca" and made it into a favorite pet, along with two dogs and five canaries.

Cutting an elegant figure, Grace Coolidge was a sought-after portrait subject. This photograph, by Canadian-born Clara Sipprell, shows Coolidge shortly after she became first lady. By 1925, Sipprell had become a well-known celebrity portraitist. Her soft-focus technique drew on early-twentieth-century pictorialist models that sought to elevate photography to an art form on a par with painting and sculpture.

Grace Anna Goodhue Coolidge (1879–1957)
Born Burlington, Vermont

———

Clara Sipprell (1885–1975)
Gelatin silver print, 8⅞ × 6⅞ in. (22.5 × 17.4 cm), c. 1925
National Portrait Gallery, Smithsonian Institution; bequest of Phyllis Fenner
S/NPG.82.74

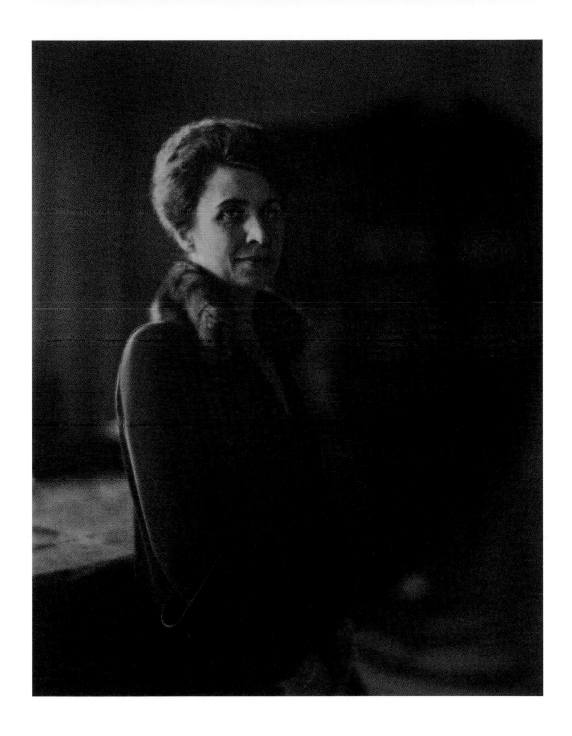

LOU HENRY HOOVER

Iowa native Lou Henry met her future husband Herbert Hoover while the two were studying at Stanford University. She was one of the first women in the United States to earn a degree in geology, and a year after her 1898 graduation, the two of them were married. Herbert Hoover's work as a mining engineer took them around the world, and she acquired fluency in several languages, including Mandarin, which she learned while living in Tianjin, China.

An avid athlete, Lou Hoover established the National Amateur Athletic Federation's Women's Division and was a lifelong leader of the Girl Scout movement. As first lady, she rejected restrictive social standards by inviting pregnant women to attend White House functions, and she defied segregationists by hosting Jessie DePriest, the African American wife of a Chicago congressman, at a White House tea for congressional wives.

Exceptionally well educated, Hoover chose to work, gaining great prestige for her 1912 translation of a technical geological text from Latin to English. However, her privilege blinded her to the challenges faced by those who maintained homes and raised children without domestic help. This disconnect alienated her from much of the nation when the Stock Market Crash of 1929 brought on the Great Depression.

This photographic portrait of Hoover by Edward Steichen was published in *Vogue* magazine. Taken in 1928, shortly before she moved into the White House, it marked the first time that this premiere fashion magazine featured a first lady in its pages.

Lou Henry Hoover (1874–1944)
Born Waterloo, Iowa

———

Edward Steichen (1879–1973)
Gelatin silver print, 9⅝ × 7¾ in. (24.5 × 19.7 cm), 1928
National Portrait Gallery, Smithsonian Institution; bequest of Edward Steichen
S/NPG.82.14

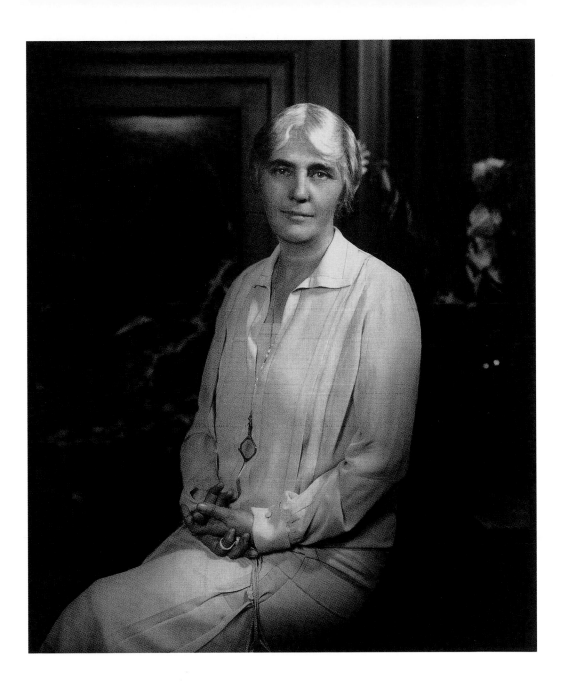

ANNA ELEANOR ROOSEVELT

Anna Eleanor Roosevelt's life changed radically when her husband (and distant cousin) Franklin Delano Roosevelt was elected to the presidency in 1932. His mobility had been limited since 1921, when he had contracted polio at the age of thirty-nine. Consequently, as first lady, Eleanor Roosevelt often made public appearances in his stead. At the height of the Great Depression, she traveled widely to assess federal relief programs, and during World War II, she flew around the world visiting troops in his place.

Despite being born into an old family of great wealth (she was the favorite niece of President Theodore Roosevelt), Eleanor Roosevelt was remarkably sensitive to the concerns of the underprivileged. Arguing that dignity came from within, she is credited with the saying "Remember, no one can make you feel inferior without your consent." After her husband's death in 1945, which came just months after his re-election to an unprecedented fourth term, she became the chairperson of the United Nations' Human Rights Commission. Her work on the articles of the Universal Declaration of Human Rights led many to hail her as the "First Lady of the World."

When photographer Yousuf Karsh made this portrait of Eleanor Roosevelt, she was already the longest-serving first lady, having lived in the White House for over a decade. She is pictured here with a pencil in hand, an allusion to her work as a journalist. Indeed, she penned over eight thousand columns for her syndicated newspaper feature, wrote twenty-seven books, and had her own radio show.

Anna Eleanor Roosevelt (1884–1962)
Born New York, New York

———

Yousuf Karsh (1908–2002)
Gelatin silver print, 12⅜ × 10¹⁄₁₆ in. (31.5 × 25.5 cm), 1944
National Portrait Gallery, Smithsonian Institution; gift of Estrellita Karsh, in memory of Yousuf Karsh
NPG.2012.77.89

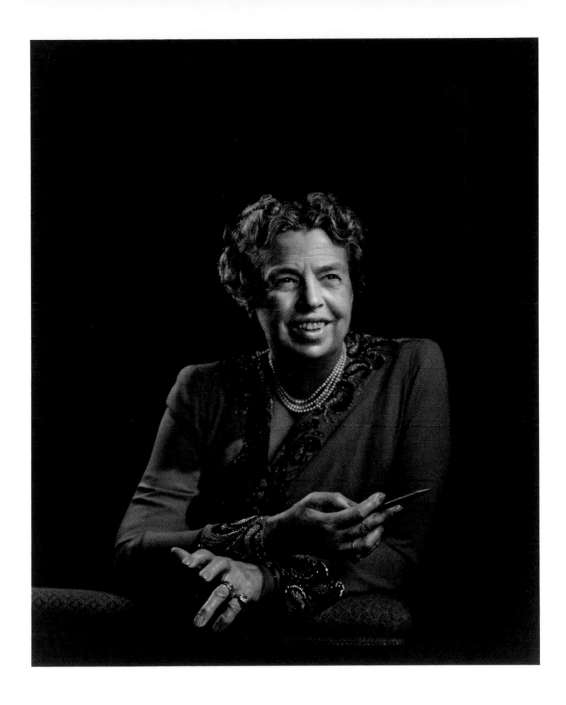

ELIZABETH "BESS" VIRGINIA WALLACE TRUMAN

Elizabeth "Bess" Virginia Wallace Truman was born into a prominent family in Independence, Missouri. As a teenager, she suffered greatly when her father died by suicide, and as a result she attempted to lead a private life as an adult. Although she was always deeply involved in her husband Harry S. Truman's political career, she has been quoted as saying that a woman's public role was "to sit beside her husband, be silent and be sure her hat is on straight."[63] Unlike her immediate predecessor, the outspoken First Lady Eleanor Roosevelt, she recoiled at the prospect of giving regular press conferences—despite the fact that she routinely helped her husband write his speeches.

As first lady, Bess Truman was instrumental in saving the White House from demolition and subsequently lobbied Congress for preservation of the mansion's original walls inside a new steel frame. After the end of World War II, she reinstated the formal social season that had been previously kept by the White House, personally overseeing the planning and organization of the traditional receptions and holiday events.

This painting of Bess Truman by Martha Greta Kempton is the pendant to her husband's official White House portrait. The Vienna-born artist painted at least three portraits of the first lady and seven of President Truman, one of which is in the National Portrait Gallery's collection of presidential portraits.

Elizabeth "Bess" Virginia Wallace Truman (1885–1982)
Born Independence, Missouri

————

Martha Greta Kempton (1903–1991)
Oil on canvas, 32 × 26 in. (81.3 × 66 cm), 1967
The White House

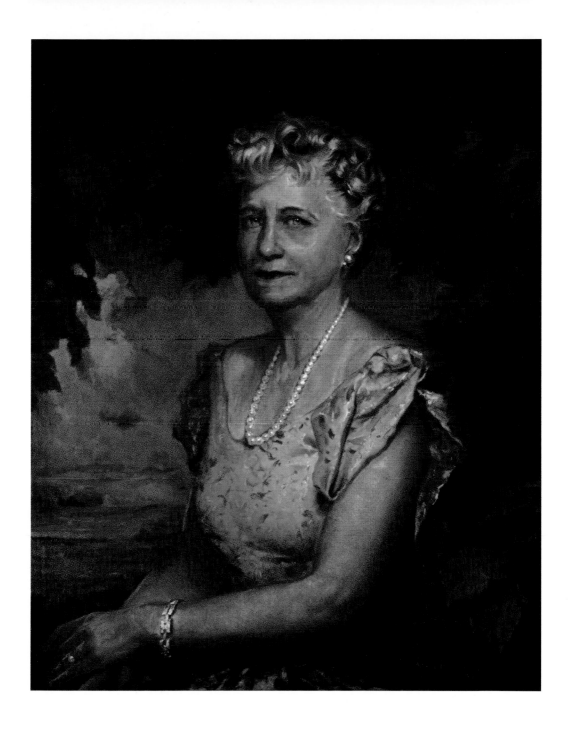

137

MAMIE GENEVA DOUD EISENHOWER

When her husband, former five-star general Dwight D. Eisenhower, was elected president in 1952, Mamie Geneva Doud Eisenhower brought her personal style and unique decorating skills to the White House. Her ebullient personality helped to popularize her signature short bangs and her favorite color, which soon became known as "Mamie Pink." Not only did it feature prominently in her wardrobe, as seen in this portrait of her in her inauguration gown, but also in much of the feminine décor that she introduced into the White House during her eight-year stay.

During the interwar years, Mamie Eisenhower had run many homes as a traveling Army wife. At the White House, her exuberant embrace of female domesticity was in harmony with a broad, postwar social campaign dedicated to encouraging middle-class white women to reprioritize home and family after so many had been drawn into the world of work during the war effort. As first lady, Eisenhower received hundreds of letters a month, and she hired additional staff to ensure that the correspondence was answered. Her welcoming attitude extended to the Easter Egg Roll, when she challenged the precedent and insisted that African American children be allowed to participate.

Mamie Geneva Doud Eisenhower (1896–1979)
Born Boone, Iowa

———

Thomas Edgar Stephens (1885–1966)
Oil on canvas, 42⅜ × 34⅜ in. (107.6 × 87.3 cm), 1959
The White House

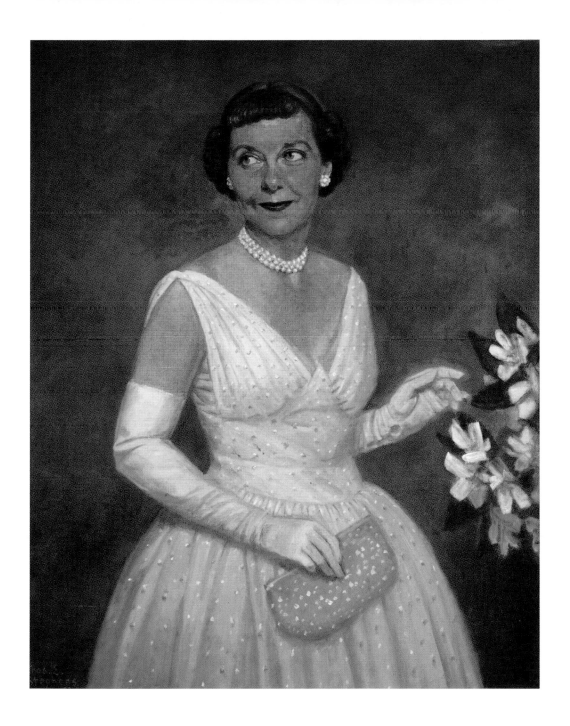

JACQUELINE LEE "JACKIE" BOUVIER KENNEDY ONASSIS

Despite her French maiden name and fluency in that language, Jacqueline Lee "Jackie" Bouvier Kennedy Onassis, like her first husband John F. Kennedy, was primarily of Irish descent. Her skillful diplomacy convinced France to loan Leonardo's *Mona Lisa* to the United States, and her interest in historic preservation helped lead to the organization of the White House Historical Association. As first lady, she experienced the death of her infant son, Patrick, just three months before witnessing her husband's gruesome assassination in 1963. Her remarkable poise during this time of unthinkable personal and national tragedy made her a symbol of strength for a nation in mourning.

Five years later, in 1968, Jackie Kennedy married the Greek shipping magnate Aristotle Onassis. Although some members of the public were angry that she had moved on, she continued to live life on her own terms, also reviving her successful career as a book editor. "Once you can express yourself, you can tell the world what you want from it," she has been quoted as saying in reference to her belief in the power of language. "All the changes in the world, for good or evil, were first brought about by words."[64]

This portrait, which was made for a 1961 *Time* magazine cover, shows a youthful first lady in front of the South Portico of the White House. The baby carriage in the background is a symbol of the young family that she and President Kennedy brought with them to the mansion.

Jacqueline Lee "Jackie" Bouvier Kennedy Onassis (1929–1994)
Born Southampton, New York

Boris Chaliapin (1904–1979)
Gouache, watercolor, colored pencil, and graphite on paperboard,
17½ × 12¼ in. (44.5 × 31.1 cm), 1960–61
National Portrait Gallery, Smithsonian Institution; gift of *Time* magazine
NPG.78.TC498

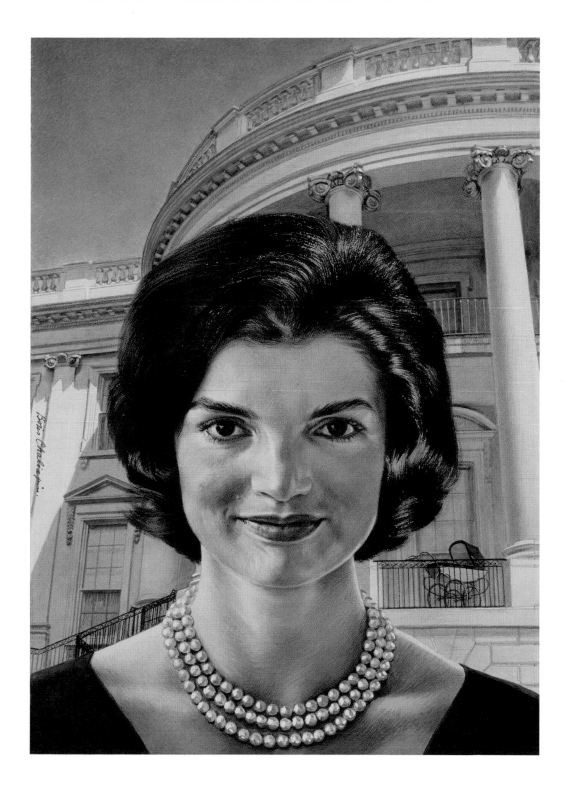

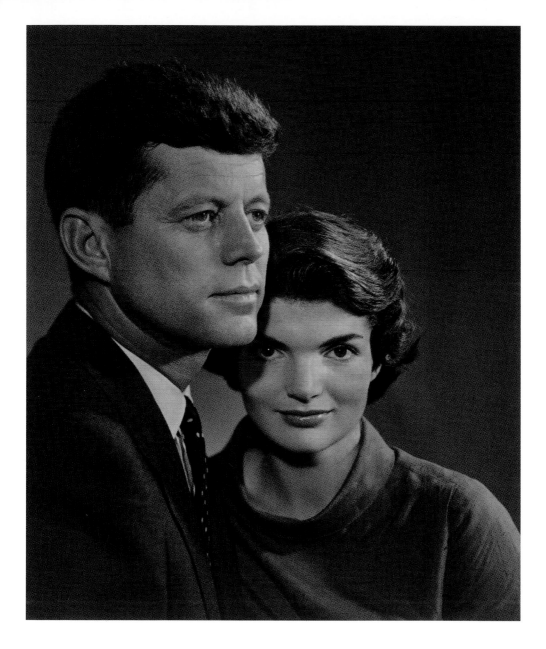

John Fitzgerald Kennedy and Jacqueline Lee Bouvier Kennedy

———————

Yousuf Karsh (1908–2002)
Gelatin silver print, 12⅜ × 10⅜ in. (31.4 × 26.3 cm), 1957
National Portrait Gallery, Smithsonian Institution; gift of Estrellita Karsh, in memory of Yousuf Karsh
NPG.2012.77.61

The Kennedy Family

———————

Bernard Safran (1924–1995)
Acrylic on Masonite, 23¼ × 16¾ in. (59 × 42.5 cm), 1960
National Portrait Gallery, Smithsonian Institution; gift of *Time* magazine
NPG.78.TC781

CLAUDIA ALTA "LADY BIRD" TAYLOR JOHNSON

When Lyndon B. Johnson was sworn in aboard Air Force One two hours after the assassination of President John F. Kennedy in 1963, Claudia Alta "Lady Bird" Taylor Johnson was unexpectedly thrust into the role of first lady. The following year, her husband ran for a full four-year term, and she broke with precedent to lead a solo campaign train trip aboard the "Lady Bird Special." This remarkable whistle-stop tour, on which she gave forty-seven speeches in eight states from Virginia to Louisiana, sought to win back the white Southern vote after President Johnson signed the Civil Rights Act of 1964. Today, Lady Bird Johnson is often associated with the 1965 Highway Beautification Act, an initiative that incorporated historic site preservation, natural resource conservation, and environmental protection. For her successful efforts, she was awarded the Presidential Medal of Freedom in 1977 and the Congressional Gold Medal in 1988.

This portrait of Lady Bird Johnson was taken by *New York Times* photographer George Tames, who photographed ten presidents, from Franklin D. Roosevelt to George H. W. Bush. A highly posed photograph, it shows the first lady framed by verdant shrubbery and holding a bouquet of large magnolia blossoms, a reminder of a native tree in her home state of Texas.

Claudia Alta "Lady Bird" Taylor Johnson (1912–2007)
Born Karnack, Texas

———

George Tames (1919–1994)
Gelatin silver print, 13⅜ × 9¹⁄₁₆ in. (33.9 × 23 cm), 1965
National Portrait Gallery, Smithsonian Institution; gift of Frances O. Tames
S/NPG.94.176

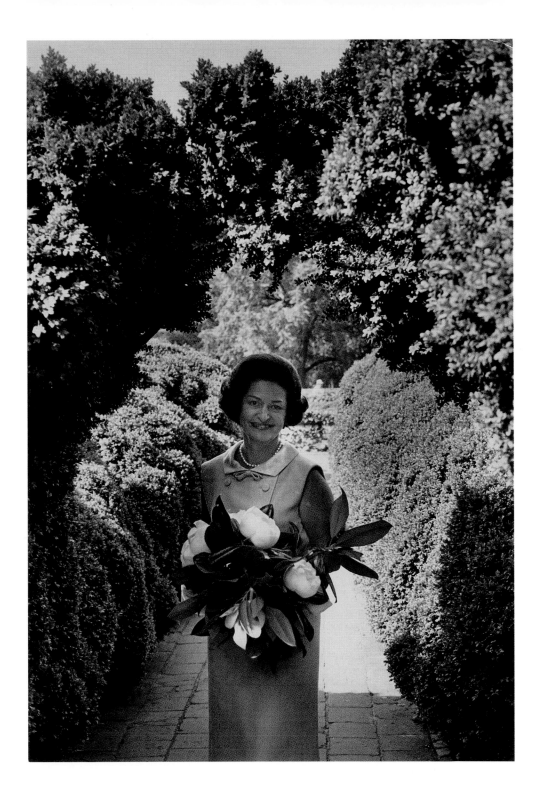

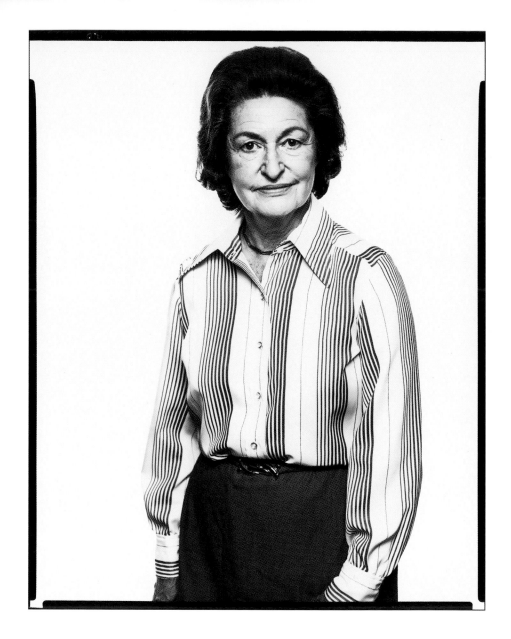

Claudia Alta "Lady Bird" Taylor Johnson

Richard Avedon (1923–2004)
Gelatin silver print, 10 × 7¹⁵⁄₁₆ in. (25.4 × 20.1 cm), 1976
National Portrait Gallery, Smithsonian Institution; this acquisition was made possible
by generous contributions from Jeane W. Austin and the James Smithson Society
NPG.89.83.30

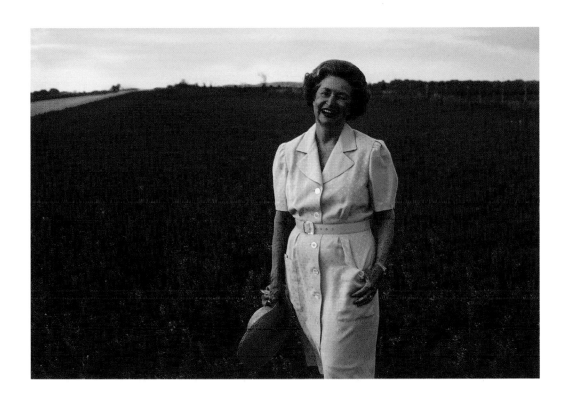

Claudia Alta "Lady Bird" Taylor Johnson

—————

Dennis Fagan (born 1953)
Inkjet print, 10¼ × 15¹⁄₁₆ in. (26.1 × 38.2 cm), 1986 (printed 2009)
National Portrait Gallery, Smithsonian Institution; gift of Jean Marie Fagan
NPG.2010.8

THELMA CATHERINE "PAT" RYAN NIXON

As a woman who had worked hard to support herself through college, Nevada-born Thelma Catherine "Pat" Ryan Nixon was a staunch advocate of the Equal Rights Amendment. During her husband Richard Nixon's vice presidency under President Dwight D. Eisenhower (1953–61) and during his own presidency, she visited over eighty countries. Pat Nixon ventured to China, the Soviet Union, a war zone in South Vietnam, and many countries in South America, including Peru, where she surveyed damage from the devastating 1970 Ancash earthquake. As first lady she regularly visited hospitals and orphanages, and her focus on access for all those wishing to visit the White House resulted in foreign-language pamphlets and the installation of the first wheelchair ramps at the mansion.

This wistful portrait of Pat Nixon gazing out a window was featured on the cover of *Time* magazine for February 29, 1960, during her husband's unsuccessful presidential run against John F. Kennedy. The artist, Robert Vickrey, was a master of egg tempera, an ancient technique that uses fast-drying egg yolk as the binder for the pigment and requires great skill to manipulate. From 1957 to 1968, Vickrey created seventy-eight covers for *Time* magazine, only a handful of which feature notable women like Pat Nixon.

Thelma Catherine "Pat" Ryan Nixon (1912–1993)
Born Ely, Nevada

———

Robert Vickrey (1926–2011)
Tempera on Masonite, 21¼ × 16⅛ in. (54 × 40.8 cm), 1960
National Portrait Gallery, Smithsonian Institution; gift of *Time* magazine
NPG.78.TC630

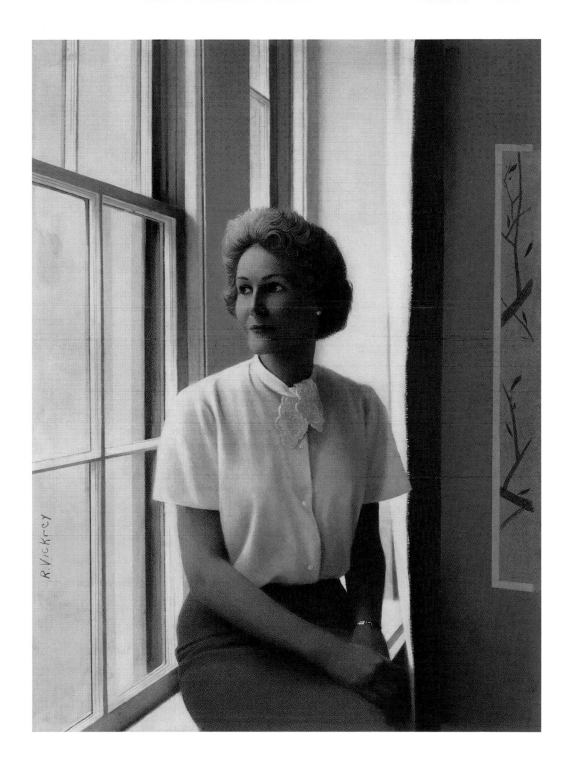

ELIZABETH "BETTY" ANNE BLOOMER FORD

Born in Chicago, Illinois, Elizabeth "Betty" Anne Bloomer performed with Martha Graham's modern dance company in New York City before marrying Gerald Ford in 1948 and entering into the world of politics. When her husband, who had spent twenty-five years as a congressman from Michigan and a short period as President Nixon's appointed vice president, was sworn in as president following Nixon's resignation in 1974, she quickly embraced her new role.

Betty Ford earned both scorn and praise for her pro-choice beliefs and her strong support of the Equal Rights Amendment. Ford was diagnosed with breast cancer and underwent a mastectomy just weeks after becoming the first lady; subsequently she encouraged women to perform self-exams and to seek early medical care. Her openness is credited with saving millions of lives. After leaving the White House, she spoke openly about her drug and alcohol dependency, which she developed after suffering from a pinched nerve and chronic arthritis. The Betty Ford Center in Rancho Mirage, California, is one result of her commitment to help others overcome substance abuse.

Artist Everett Kinstler painted this vibrant portrait of Betty Ford in 1996, two years before she and her husband won the Congressional Gold Medal. Kinstler also painted Gerald Ford's White House portrait (1977) and the portrait of him that is in the National Portrait Gallery's collection (1987).

Elizabeth "Betty" Anne Bloomer Ford (1918–2011)
Born Chicago, Illinois

Everett Raymond Kinstler (1926–2019)
Oil on canvas, 20 × 16 in. (50.8 × 40.6 cm), 1996
National Portrait Gallery, Smithsonian Institution; gift of Everett Raymond Kinstler
NPG.97.155

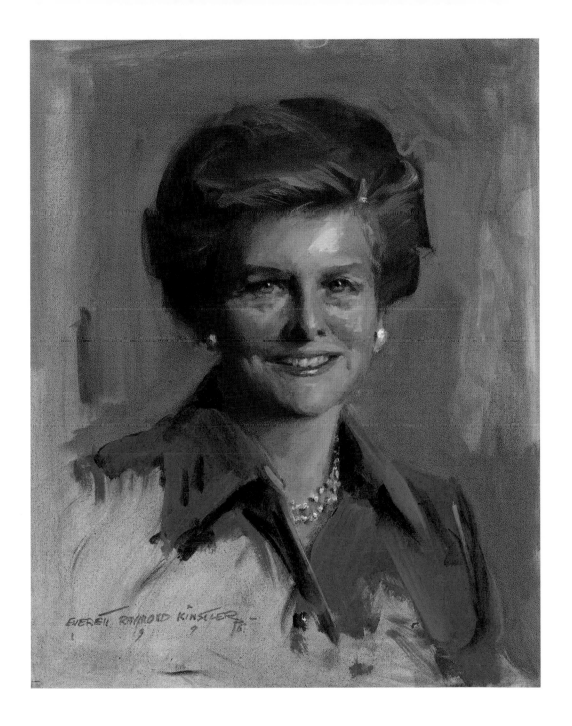

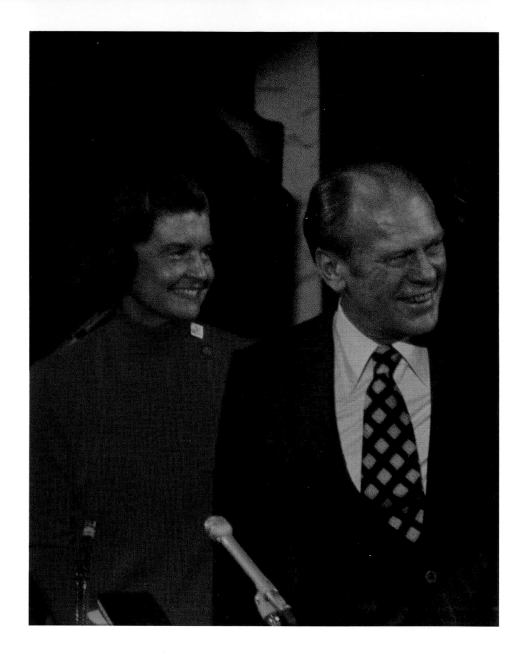

Gerald and Betty Ford

David Hume Kennerly (born 1947)
Chromogenic print, 9½ × 7½ in. (24.2 × 19.1 cm), 1973
National Portrait Gallery, Smithsonian Institution; gift of *Time* magazine
NPG.78.TC380

Gerald Ford and Family

———

David Hume Kennerly (born 1947)
Chromogenic print, 14 × 11 in. (35.6 × 27.9 cm), 1975
National Portrait Gallery, Smithsonian Institution; gift of *Time* magazine
NPG.78.TC379

ELEANOR ROSALYNN SMITH CARTER

Eleanor Rosalynn Smith Carter, who became a strong advocate of social welfare programs, was born in Plains, Georgia, as was her husband, Jimmy Carter. During his campaign for governor of Georgia in 1970, she listened to voters' concerns about mental health care and brought the issue with her to the White House in 1977. In addition to serving as honorary chair of the President's Commission on Mental Health, she chose to attend cabinet meetings so that she could give informed answers to the questions she received at public appearances.

Even though President Carter only served one term, Rosalynn Carter's promotion of the Mental Health Systems Act during his re-election campaign was instrumental to the act's passage during the following administration. In 1982, Rosalynn and Jimmy Carter founded the Carter Center, which continues to promote mental health care, among many other causes. Since 1984, the annual Jimmy and Rosalynn Carter Work Project with Habitat for Humanity has built and renovated houses in the United States and across the globe that serve as physical embodiments of the Carters' humanitarian principles.

Shortly before Jimmy Carter was elected president in 1976, artist Robert Clark Templeton sketched Rosalynn Carter from two different angles, suggesting her multifaceted character and interests. The slightly upturned corners of her mouth convey a strong sense of the serenity with which she would approach the position of first lady. Templeton's 1980 portrait of President Jimmy Carter is also in the collection of the National Portrait Gallery.

Eleanor Rosalynn Smith Carter (born 1927)
Born Plains, Georgia

———

Robert Clark Templeton (1929–1991)
Pastel on illustration board, 25½ × 19⅝ in. (64.8 × 49.8 cm), 1976
National Portrait Gallery, Smithsonian Institution;
donated by Mark, Kevin, and Tim Templeton, sons of the artist
NPG.2013.70

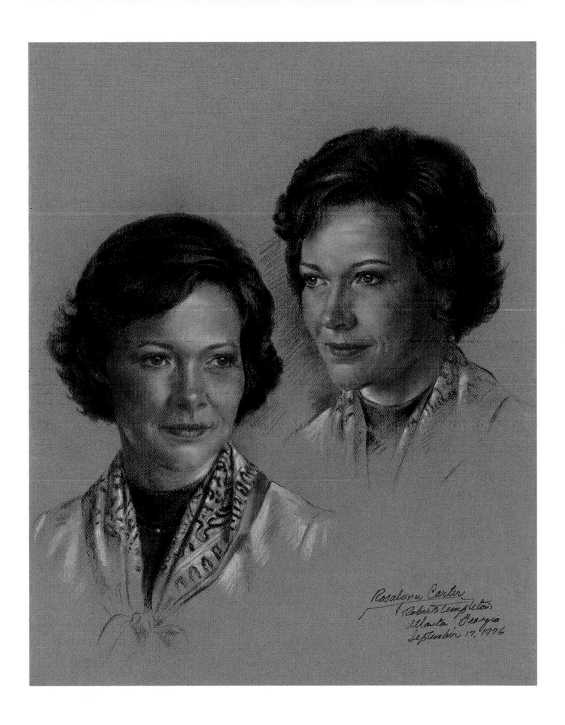

Rosalynn Carter
Robert Templeton
Atlanta, Georgia
September 17, 1976

NANCY DAVIS REAGAN

After marrying fellow actor and aspiring politician Ronald Reagan in 1952, Nancy Davis Reagan (born Anne Frances Robbins) became his closest political advisor and fiercest protector during a long political career that began with his election as governor of California in 1966 and continued through his presidency. As first lady, she led the "Just Say No" campaign, an effort to alert children to the dangers of illegal drugs. She also supported passage of the 1986 Anti-Drug Abuse Act, which dramatically increased penalties for users and dealers of some types of controlled substances. Taking the issue to an international level, Reagan addressed the General Assembly of the United Nations in 1988 about the impact of international drug trafficking. No prior first lady had addressed the General Assembly.

During her years in the White House, Reagan was criticized for her lavish designer wardrobe. She also drew ire for ordering a 4,370-piece set of custom china, although it was funded privately. This trend toward opulence during a period of "trickle-down economics" earned her the derisive nickname "Queen Nancy." Detractors found her actions inappropriate when the nation was facing record homelessness and the AIDS epidemic was claiming the lives of thousands.

This likeness of Reagan by Aaron Shikler, who also painted her official White House portrait, shows her wearing a dress in "Reagan Red," her signature color. The image ran on the January 14, 1985, cover of *Time* magazine and was accompanied by a headline that hailed her as the "White House Co-Star."

Nancy Davis Reagan (1921–2016)
Born New York, New York

———

Aaron Shikler (1922–2015)
Oil on paper, 25⅞ × 19¹⁵/₁₆ in. (65.7 × 50.7 cm), 1984–85
National Portrait Gallery, Smithsonian Institution; gift of *Time* magazine
NPG.88.TC160

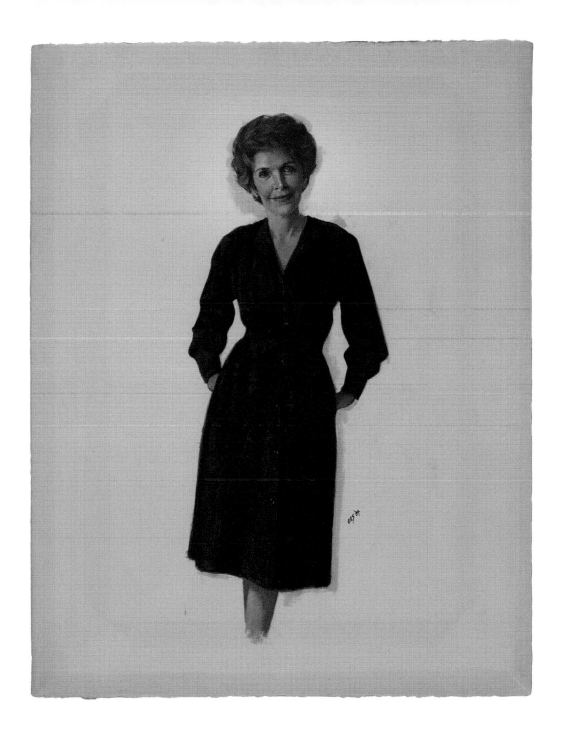

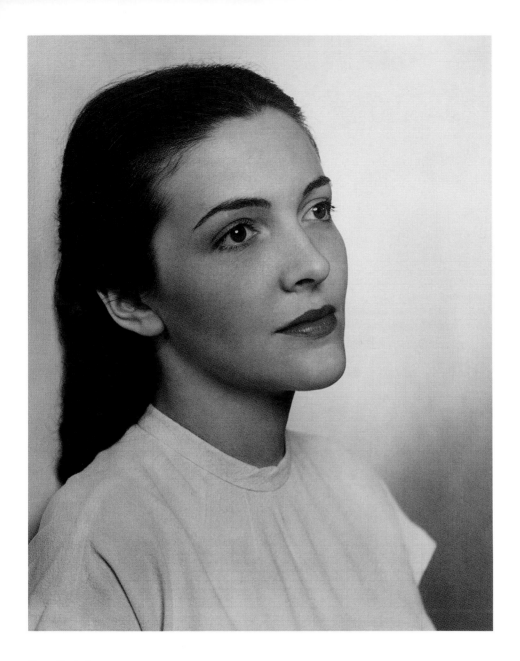

Nancy Davis Reagan

————————

Philippe Halsman (1906–1979)
Gelatin silver print, 13⅝ × 10⁹⁄₁₆ in. (34.6 × 26.8 cm), 1945
National Portrait Gallery, Smithsonian Institution; gift of George R. Rinhart
S/NPG.82.56

Nancy Davis Reagan

————

Diana Walker (born 1942)
Inkjet print, 12⅛ × 17⁹⁄₁₆ in. (30.8 × 44.6 cm), 1982 (printed 2011)
National Portrait Gallery, Smithsonian Institution; gift of Diana Walker
NPG.2011.38

BARBARA PIERCE BUSH

Following Abigail Adams, Barbara Pierce Bush is only the second woman to have been the wife of one president and the mother of another; she also shared a common ancestor with President Franklin Pierce. A strong supporter of the Equal Rights Amendment, Bush was pro-choice and fought to destigmatize AIDS. Believing that education could elevate all people, as first lady she used her platform to combat illiteracy, writing several books and hosting a radio program with celebrity guests called "Mrs. Bush's Story Time." Her campaign work did not end when she and her husband George H. W. Bush left the White House; instead, she continued her political involvement by supporting the presidential campaigns of her two eldest sons, George W. Bush and Jeb Bush.

This portrait by Diana Walker, who photographed the Reagan, Bush, and Clinton administrations for *Time* magazine, shows the first lady and the family dog Millie going for a walk on the White House grounds in 1989. That year, Barbara Bush established the Barbara Bush Foundation for Family Literacy to improve access to educational opportunities; it was funded in part by the proceeds of *Millie's Book*, which "describes a day in the life of George Herbert Walker Bush and family, discussing morning briefings, deliberations in the Oval Office, and short breaks for squirrel hunting."[65]

Barbara Pierce Bush (1925–2018)
Born New York, New York

———————

Diana Walker (born 1942)
Inkjet print 11¹⁵⁄₁₆ × 17½ in. (30.4 × 44.4 cm), 1989 (printed 2010)
National Portrait Gallery, Smithsonian Institution; gift of Diana Walker
NPG.2011.50

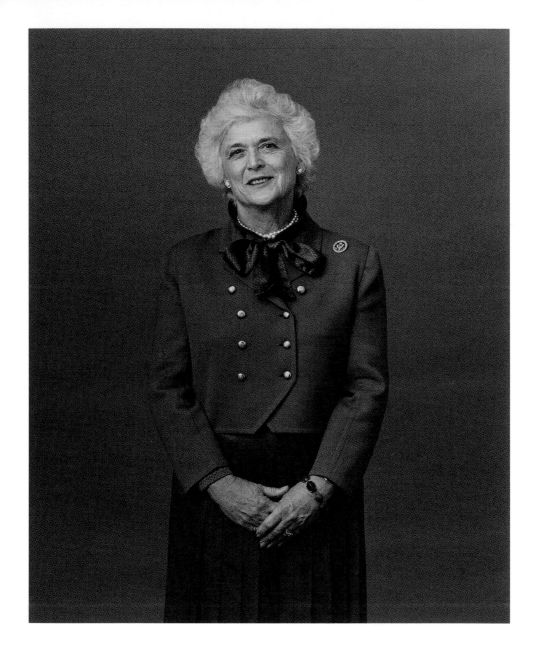

Barbara Pierce Bush

————

Michael Arthur Worden Evans (1944–2005)
Gelatin silver print, 21⅞ × 17⅝ in. (55.6 × 44.8 cm), c. 1984
National Portrait Gallery, Smithsonian Institution; gift of the Portrait Project, Inc.
S/NPG.92.194

George and Barbara Bush

Diana Walker (born 1942)
Chromogenic print, 10¼ × 14¾ in. (26.1 × 37.5 cm), 1988
National Portrait Gallery, Smithsonian Institution; gift of Diana Walker
S/NPG.95.113

HILLARY DIANE RODHAM CLINTON

Not only did Hillary Diane Rodham Clinton spend eight years as first lady of the United States during her husband Bill Clinton's presidency, but she also went on to be elected a US senator from New York, serve as US secretary of state, and become the first woman to receive the presidential nomination from the Democratic Party. Raised in Chicago, Illinois, she attended Wellesley College and received a law degree from Yale University. As first lady, she headed the White House's Task Force on National Health Care Reform and stoically stood by her husband as he was impeached by Congress during his embattled second term. She has authored several books, including *It Takes a Village: And Other Lessons Children Teach Us* (1996), and she and her daughter, Chelsea Clinton, wrote *The Book of Gutsy Women: Favorite Stories of Courage and Resilience* (2019).

Ginny Stanford's painting of Hillary Clinton is the first portrait of a first lady to be commissioned by the National Portrait Gallery. Subsequently, every first lady has been honored in this way. "There was so much warmth and humor that I sensed from her in person, and she hadn't been portrayed like that in public," Stanford later recalled about her initial meeting with the former first lady. "I felt really excited about the possibility of portraying this side of her."[66]

Hillary Diane Rodham Clinton (born 1947)
Born Chicago, Illinois

———

Ginny Stanford (born 1950)
Center panel: acrylic on canvas on wood panel; side panels: gold leaf on wood stretcher; overall: 32 × 42½ in. (81.3 × 108 cm), 2006
National Portrait Gallery, Smithsonian Institution; gift of Ambassador Elizabeth F. Bagley and Mr. Smith Bagley, Robert B. Barnett, Susie Tompkins Buell, The Boeing Company, Buffy and William Cafritz, David V. and Judith E. Capes, Albert and Claire Dwoskin, Catherine Spitzer Gidlow, Jill and Kenneth Iscol, Ambassador and Mrs. Philip Lader, Ruesch Family Foundation, Corky Hale and Mike Stoller, and Leon and Mary Strauss
NPG.2006.2

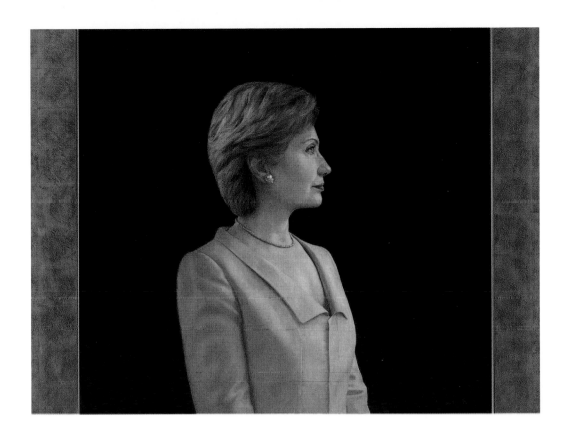

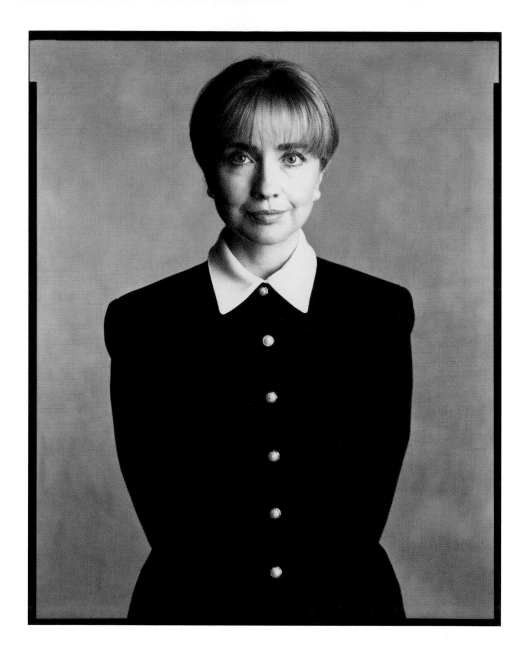

Hillary Diane Rodham Clinton

———————

Timothy Greenfield-Sanders (born 1952)
Gelatin silver print, 10¹⁄₁₆ × 8 in. (25.5 × 20.3 cm), 1994
National Portrait Gallery, Smithsonian Institution; gift of Ruth and Richard Shack
S/NPG.94.281

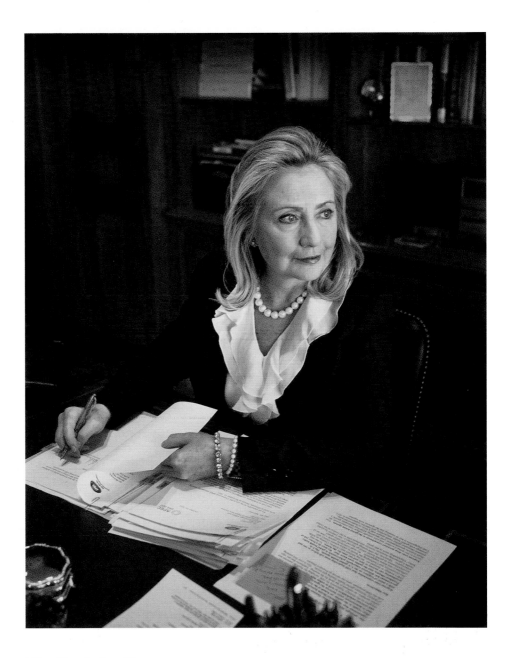

Hillary Diane Rodham Clinton

Diana Walker (born 1942)
Gelatin silver print, 13½ × 10½ in. (34.3 × 26.6 cm), 2011
National Portrait Gallery, Smithsonian Institution; gift of Diana Walker
NPG.2012.75

LAURA LANE WELCH BUSH

When Laura Lane Welch Bush entered the White House, she had been advocating for childhood literacy for decades. Having begun her career as an elementary school teacher, she went on to earn a master's degree in library science from the University of Texas, Austin, and then worked as a school librarian. As first lady, she established the Laura Bush Foundation for America's Libraries, which continues to provide funds to school libraries that are affected by economic hardship and natural disasters. Later, she became the founding ambassador for The Heart Truth, bringing public awareness to women's heart disease, and initiated international partnerships to advance breast cancer research.

Following the terrorist attacks on September 11, 2001, Laura Bush became the "comforter in chief" for many people in the United States, and the two wars that followed often obscured her efforts to focus on children's education and women's welfare.

In this portrait, Aleksander Titovets portrays Laura Bush in the private quarters of the White House, holding a book. Siberian-born Titovets immigrated to the United States from Russia after studying art in St. Petersburg. Today, he makes his home in El Paso, Texas, about a day's drive from Crawford, Texas, the location of Laura and George Bush's ranch (once known as the "Western White House").

Laura Lane Welch Bush (born 1946)
Born Midland, Texas

———

Aleksander Titovets (born 1960)
Oil on canvas, 38 ¾ × 36 in. (98.4 × 91.4 cm), 2008
National Portrait Gallery, Smithsonian Institution; gift of Mr. and Mrs. J. O. Stewart
NPG.2008.38

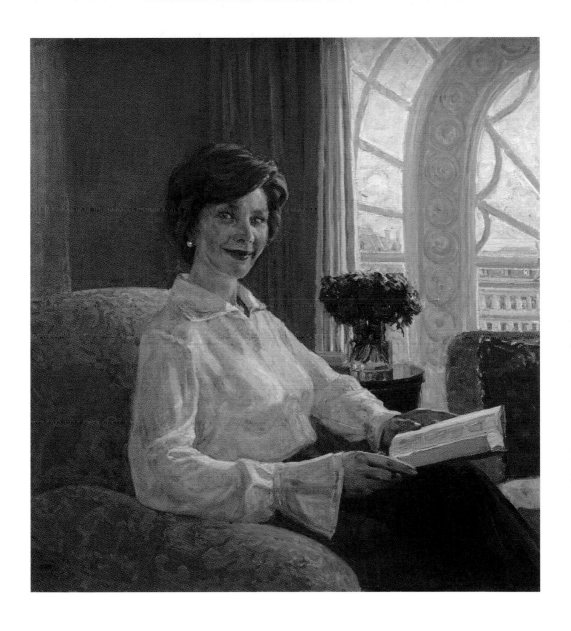

MICHELLE LAVAUGHN ROBINSON OBAMA

After graduating from Princeton University, Michelle LaVaughn Robinson earned a law degree from Harvard University. She then returned to her hometown of Chicago, where she met her future husband, Barack Obama, while working in intellectual property law. Before President Obama's election in 2008, her career had taken her from city government and nonprofit work to university and hospital administration. As the first lady and as the mother of two daughters, Obama was inspired to reach young people through various health and education initiatives that included Let's Move, Reach Higher, and Let Girls Learn, the latter of which fought to ensure that girls worldwide were afforded equal access to learning opportunities. Today, Obama continues to work toward empowering others, and her best-selling book *Becoming* (2018) has inspired readers around the globe.

When this portrait was unveiled at the National Portrait Gallery in 2018, many viewers were pleased, while others were shocked by Amy Sherald's distinctive approach. The artist later responded to their primary criticism: "'You have a First Lady who is a black woman, and she should have black skin.' To me when you see brown skin, it tends to codify something. So through the gray you're almost allowed to look past that into the real person." [67]

Michelle LaVaughn Robinson Obama (born 1964)
Born Chicago, Illinois

Amy Sherald (born 1973)
Oil on linen, 72⅛ × 60⅛ in. (183.2 × 152.7 cm), 2018
National Portrait Gallery, Smithsonian Institution; gift of Kate Capshaw and Steven Spielberg; Judith Kern and Kent Whealy; Tommie L. Pegues and Donald A. Capoccia; Clarence, DeLoise, and Brenda Gaines; Jonathan and Nancy Lee Kemper; The Stoneridge Fund of Amy and Marc Meadows; Robert E. Meyerhoff and Rheda Becker; Catherine and Michael Podell; Mark and Cindy Aron; Lyndon J. Barrois and Janine Sherman Barrois; The Honorable John and Louise Bryson; Paul and Rose Carter; Bob and Jane Clark; Lisa R. Davis; Shirley Ross Davis and Family; Alan and Lois Fern; Conrad and Constance Hipkins; Sharon and John Hoffman; Audrey M. Irmas; John Legend and Chrissy Teigen; Eileen Harris Norton; Helen Hilton Raiser; Philip and Elizabeth Ryan; Roselyne Chroman Swig; Josef Vascovitz and Lisa Goodman; Eileen Baird; Dennis and Joyce Black Family Charitable Foundation; Shelley Brazier; Aryn Drake-Lee; Andy and Teri Goodman; Randi Charno Levine and Jeffrey E. Levine; Fred M. Levin and Nancy Livingston, The Shenson Foundation; Monique Meloche Gallery, Chicago; Arthur Lewis and Hau Nguyen; Sara and John Schram; Alyssa Taubman and Robert Rothman
NPG.2018.15

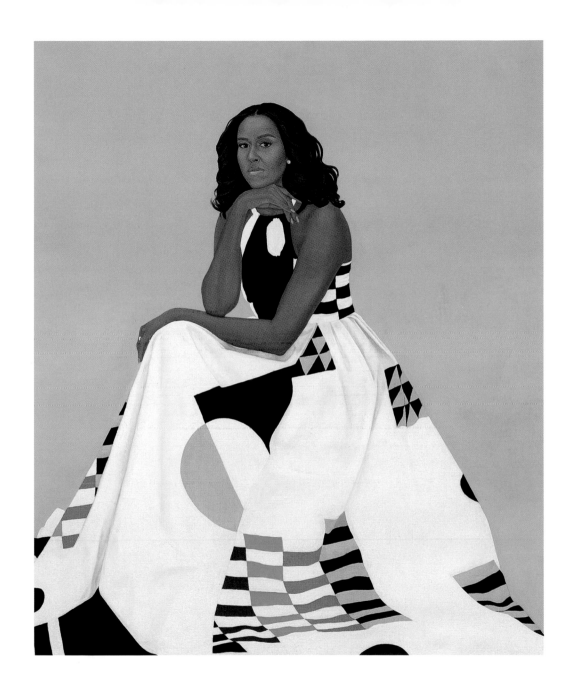

MELANIA KNAUSS TRUMP

Melania Knauss Trump, shown here in her official White House portrait, was born in Slovenia when it was part of the former Yugoslavia. Along with Louisa Catherine Johnson Adams, Trump is only the second first lady to have been born outside of the United States. With the care of her young son Barron as her primary focus, Trump has tackled the difficult task of protecting his privacy while serving as first lady. Since being thrust onto the public stage with her husband Donald Trump's run for president in 2016, she has quietly focused on social welfare–oriented nonprofit work with organizations such as the Red Cross.

Melania Trump's commitment to the well-being of children has been realized through her Be Best campaign. This international initiative supports programs for children's welfare with a focus on three specific issues: well-being, online safety, and combatting opioid abuse. During the early days of the COVID-19 pandemic, she actively used her @FLOTUS Twitter account to promote information on health and safety while encouraging parents to remain attentive to the needs of their children.[68]

Melania Knauss Trump (born 1970)
Born Novo Mesto, Yugoslavia (now Slovenia)

———

Régine Mahaux (born 1967)
Photograph, 30 × 20 in. (76.2 × 50.8 cm), 2017
The White House

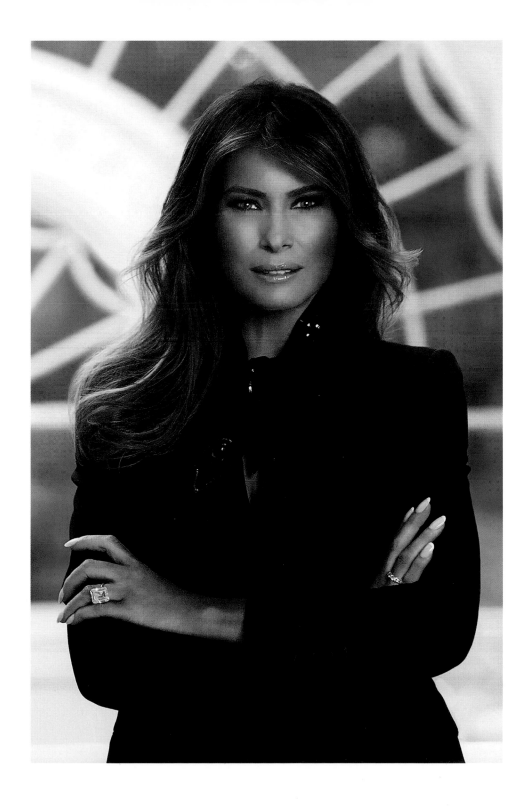

Endnotes

1 Julia Gardiner Tyler to Juliana Tyler, July 1844, Tyler Family Papers, cited in Robert Seager II, *And Tyler Too: A Biography of John and Julia Tyler* (New York: McGraw Hill, 1963), 10 and 558n.18.

2 See Patricia Cohen, "Mrs. Lincoln, I Presume? Well, as It Turns Out ...," *New York Times,* February 11, 2012, nytimes.com.

3 "Martha on $1," mountvernon.org/george-washington/martha-washington/martha-on-1.

4 The official residence of the president has changed over the country's history. Following the signing of the Articles of Confederation in 1781, Philadelphia was the primary location of the capital of the United States; in 1800, that honor moved permanently to the newly constructed city of Washington, D.C. However, during and immediately following the Revolutionary War, seven other cities, including New York City, served as temporary capitals. As president and first lady, George and Martha Washington occupied residences in New York and Philadelphia.

 Over time, various designations have been used to describe the residences of the presidents, including the President's House, the Presidential Mansion, and the White House. Just as any Air Force aircraft on which the commander-in-chief rides may be referred to as Air Force One while he is aboard, so, too, is any home that he occupies considered to be his official residence.

5 Martha Washington to Fanny Bassett Washington, October 23, 1789. Martha Washington, Item #13, marthawashington.us/items/show/13.

6 Martha Washington to Mercy Otis Warren, December 26, 1789. Martha Washington, Item #25, marthawashington.us/items/show/25.

7 See Grace Coolidge, *Grace Coolidge: An Autobiography,* ed. Lawrence E. Wikander and Robert H. Ferrell (Worland, WY: High Plains, 1992), 62. Coolidge is also quoted in Robert H. Ferrell, *Grace Coolidge: The People's Lady in Silent Cal's White House* (Lawrence: University Press of Kansas, 2008), 57.

8 Sarah Polk, quoted in Anson and Fanny Nelson, *Memorials of Sarah Childress Polk: Wife of the Eleventh President of the United States* (New York: Anson D. F. Randolph, 1892), 80.

9 Mrs. William Howard Taft, *Recollections of Full Years* (New York: Dodd, Mead, and Company, 1914), 365.

10 "Swedish Painter Lauds Beauty of American Women," *Wichita Daily Eagle* (Wichita, KS), September 25, 1910.

11 Florence Harding, quoted in John Whitcomb and Claire Whitcomb, *Real Life at the White House: 200 Years of Daily Life at America's Most Famous Residence* (New York: Routledge, 2002 [2000]), 263.

12 Ellen Louise Axson Wilson to William Howard Taft, January 10, 1913, series 7, case file 723, William H. Taft Papers, Library of Congress. Manuscript Division. Quoted in Nancy Kegan Smith and Mary C. Ryan, *Modern First Ladies: Their Documentary Legacy* (Washington, D.C.: National Archives and Records Administration, 1989), 32.

13 Herndon was the captain of the ship, whose wreck contributed to the Panic of 1857.

14 Edith Bolling Galt Wilson, *My Memoir* (Indianapolis: Bobbs-Merrill Company, 1939), 289.

15 From Isabella Hagner's typescript memoirs, now in the White House collection in the Isabella Hagner James Papers in the Office of the Curator, whitehousehistory.org/memoirs-of-isabella-hagner-1901-1905 and whitehousehistory.org/photos/edith-and-ethel-roosevelt.

16 Jose de la Puente, quoted in Virginia A. Chanley, "The First Lady as Presidential Advisor, Policy Advocate, and Surrogate: Rosalynn Carter and the Political Role of the First Lady." *White House Studies* 1, no. 4 (2001): 549, Gale Academic OneFile.

17 See "Beautification: A Legacy of Lady Bird Johnson" by the National Park Service: https://www.nps.gov/articles/lady-bird-johnson-beautification-cultural-landscapes.htm. Also see the website for the Lady Bird Johnson Wildflower Center at the University of Texas at Austin: ladybirdjohnson.org.

18 Lady Bird Johnson, *A White House Diary* (Austin: University of Texas Press, 2007), 8.

19 Jane Pierce, quoted in Brian Matthew Jordan, *Triumphant Mourner: The Tragic Dimension of Franklin Pierce* (Pittsburgh: Dorrance, 2003), 45.

20 Nancy Reagan, *My Turn: The Memoirs of Nancy Reagan* (New York: Random House, 2011). Quoted in Del Quentin Wilber, "How the 1981 Assassination Attempt Changed Nancy Reagan," *Los Angeles Times,* March 11, 2016, latimes.com.

21 E. B. Duffey, *The Ladies' and Gentlemen's Etiquette: A Complete Manual of the Manners and Dress of American Society* (Philadelphia: Porter and Coates, 1877), 178.

22 Louisa Catherine Adams, miscellany, March 1, 1819, Adams Family Papers, Massachusetts Historical Society, quoted in Catherine Allgor, *A Perfect Union: Dolley Madison and the Creation of the American Nation* (New York: Henry Holt, 2007), 183.

23 Betty Boyd Caroli, *First Ladies: From Martha Washington to Michelle Obama*, rev. ed. (New York: Oxford University Press, 2010), 75.

24 "Didn't You Know, My Dears?" Widely published editorial that appeared in *Journal Gazette* and the *Desert Sun*, March 2, 1978, quoted in "White House Etiquette and Tone," Thursday, October 19, 2017, http://etiquipedia.blogspot.com/2017/10/white-house-etiquette-and-tone.html.

25 Ibid.

26 Abigail Adams to John Adams, March 31, 1776. See an image of the letter dated March 31–April 5, 1776, on the Massachusetts Historical Society's website at https://www.masshist.org/digitaladams/archive/doc?id=L17760331aa. Adams Family Papers: An Electronic Archive. Massachusetts Historical Society.

27 Rachel Jackson, quoted in Augustus C. Buell, *History of Andrew Jackson: Pioneer, Patriot, Soldier, Politician, President* (New York: Charles Scribner's Sons, 1904), 200.

28 Catherine Allgor's book *A Perfect Union: Dolley Madison and the Creation of the American Nation* (New York: Henry Holt and Company, 2007) provides an excellent discussion of Madison's role as a hostess and the ways it has come to overshadow her other achievements.

29 Dolley Madison to Anna Payne Cutts, August 23, 1814, nationalcenter.org/WashingtonBurning1814.html. Dolley Madison's account of saving the "Lansdowne" portrait has been disputed by a number of credible sources. Today, scholars believe that while she may have instructed free and enslaved servants to remove the portrait from its frame and transport it to safety, she herself was not further involved in its deinstallation. See Hilarie M. Hicks, "The Great Portrait Rescue: A Historical Whodunit," *Digging Deeper* (blog), *Montpelier's Digital Doorway*, August 22, 2019: https://digitaldoorway.montpelier.org/diggingdeeper/page/3/.

30 The first ladies who did not live to see their husband take office as the president are Martha Wayles Jefferson, Rachel Donelson Robards Jackson, Hannah Hoes Van Buren, and Ellen Lewis Arthur.

31 During the nineteenth century, the maternal death rate for women in the United States was around 0.4%; today, because of advances in medicine and improvements in health care, it is 0.05%. See "Achievements in Public Health, 1900–1999: Healthier Mothers, Healthier Babies." https://www.cdc.gov/mmwr/preview/mmwrhtml/mm4838a2.htm.

32 Isaac Granger Jefferson, *Memoirs of a Monticello Slave*, ed. Rayford W. Logan (Charlottesville: University of Virginia Press, 1951), 14. Quoted at https://www.monticello.org/site/research-and-collections/martha-wayles-skelton-jefferson.

33 Mamie Eisenhower, quoted in Gil Troy, *Affairs of State: The Rise and Rejection of the Presidential Couple Since World War II* (New York: Free Press, 1997), 54.

34 Matthew Schneier, "Nancy Reagan's Love of Fashion Recalled at Givenchy Show," *New York Times*, March 6, 2016, nytimes.com.

35 Jacqueline Kennedy Onassis, quoted in Bill Adler, *The Eloquent Jacqueline Kennedy Onassis: A Portrait in Her Own Words* (New York: Zondervan, 2009), 88.

36 Barbara Bush, quoted in Joslyn Pine, ed., *Wit and Wisdom of America's First Ladies: A Book of Quotations* (Mineola, NY: Dover, 2014), 214. Also visit the George W. Bush Presidential Library and Museum website https://www.georgewbushlibrary.smu.edu/en/The-President-and-Family/Trivia/First-Ladies-Trivia?p=1.

37 Only two of Martha Washington's four children from her marriage with Daniel Park Custis lived past three years old. She did not have any children with George Washington.

38 Martha Washington to Mercy Otis Warren, December 26, 1789. See Joseph E. Fields, ed., *"Worthy Partner": The Papers of Martha Washington* (Westport, CT: Greenwood, 1994).

39 In the March 31, 1776, letter to John Adams, Abigail Adams wrote, "I long to hear that you have declared an independency—and by the way in the new Code of Laws which I suppose it will be necessary for you to make I desire you would Remember the Ladies, and be more generous and favourable to them than your ancestors," https://www.masshist.org/digitaladams/archive/doc?id=L17760331aa.

40 Part of this paragraph is an excerpt of a National Portrait Gallery blog entry about the painting, https://npg.si.edu/blog/portrait-dolley-madison-william-elwell.

41 For more background on the lives of James and Elizabeth Monroe during this period, see Jon Kukla, *A Wilderness So Immense: The Louisiana Purchase and the Destiny of America* (New York: Anchor Books, 2003), esp. 46–52.

42 See Mary Emily Donelson Wilcox, "Andrew Jackson. His Life, Times, and Compatriots. Ninth Paper. Rachel Donelson Jackson. Part I," *Frank Leslie's Popular Monthly* 46, no. 1 (July 1898): 26 cit.; 24–32.

43 Ibid., 29.

44 The obituary published in the *Albany Argus* newspaper by her pastor, John Chester, is the primary source of information about Van Buren's life. It is extensively quoted in Paul F. Boller, *Presidential Wives* (New York: Oxford University Press, 1998 [1988]), 73–74.

45 See Andrew R. L. Cayton, "The World of Anna Tuthill Symmes Harrison," in *Frontier Indiana* (Bloomington and Indianapolis: Indiana University Press, 1998 [1996]), 167–68. While he was unhappy at the time of their marriage, he later gave the couple his blessing.

46 See Margaret Brown Klapthor and Allida Mae Black, *The First Ladies*, 10th ed. (Washington, D.C.: White House Historical Association with the National Geographic Association, 2001), 27.

47 For information on Letitia Tyler and the plantation, see the 1936 National Register of Historic Places nomination form for Cedar Grove, https://www.dhr.virginia.gov/wp-content/uploads/2018/04/063-0036_Cedar_Grove_1979_Final_Nomination.pdf.

48 In 1799, the New York legislature adopted the Gradual Emancipation Act, which stipulated that children born to enslaved adults would be indentured (rather than enslaved) until they reached adulthood. In 1817, the state passed another law that mandated the emancipation of all enslaved people by 1827. The reality was that many enslaved people either did not learn of their right to freedom (this was the case for Sojourner Truth), or had little choice but to remain as servants to their former masters following their nominal freedom. For more information on slavery in New York, see https://www.nyhistory.org/community/slavery-end-new-york-state.

49 See Evelyn L. Pugh, "Women and Slavery: Julia Gardiner Tyler and the Duchess of Sutherland," *The Virginia Magazine of History and Biography* 88, no. 2 (April 1980): 186–202.

50 See "Cokie Roberts on Founding Mothers" in David M. Rubenstein, *The American Story: Conversations with Master Historians* (New York: Simon and Schuster, 2019), 134.

51 Klapthor and Black, *The First Ladies*, 36.

52 Eliza Johnson, quoted in Susan Swain and C-SPAN, *First Ladies: Presidential Historians on the Lives of 45 Iconic American Women* (New York: PublicAffairs, 2015), 132.

53 Interview with Mary Robinson, a formerly enslaved woman who worked at White Haven, the Dent family farm in St. Louis, Missouri, *St. Louis Republican*, July 24, 1885. Quoted in Joan Waugh, *U. S. Grant: American Hero, American Myth* (Chapel Hill: University of North Carolina Press, 2009), 43.

54 William H. Crook, "Rutherford B. Hayes in the White House," *The Century Magazine*. Quoted in Russell L. Mahan, *Lucy Webb Hayes: A First Lady by Example*. A Volume in the Presidential Wives Series (New York: Nova Science, 2011), 80.

55 Mary C. Ames, quoted in Charles Carleton Coffin, *The Life of James A. Garfield* (Boston: James H. Earle, 1880), 337.

56 Lucretia Garfield to James Garfield, June 5, 1877. Quoted in John Shaw, *Crete and James: Personal Letters of Lucretia and James Garfield* (East Lansing: Michigan State University Press, 1994), 342.

57 The window is still featured prominently in the church. The inscription reads, "To the glory of God and in memory of Ellen Lewis Herndon Arthur, entered into life January 19, 1880."

58 Lila Graham Alliger Woolfall, *Presiding Ladies of the White House: Containing Biographical Appreciations Together with a Short History of the Executive Mansion and a Treatise on Its Etiquette and Customs* (Washington, D.C.: Bureau of National Literature and Art, 1903), 99.

59 Rose Elizabeth Cleveland, *Precious and Adored: The Love Letters of Rose Cleveland and Evangeline Simpson Whipple, 1890–1918*, ed. Lizzie Ehrenhalt and Tilly Laskey (St. Paul: Minnesota Historical Society Press, 2019).

60 Isabella Hagner (typescript memoirs), Isabella Hagner James Papers, Office of the Curator, the White House, https://www.whitehousehistory.org/memoirs-of-isabella-hagner-1901-1905 and https://www.whitehousehistory.org/photos/edith-and-ethel-roosevelt.

61 Taft, *Recollections of Full Years*, 332.

62 Lillian Rogers Parks in collaboration with Frances Spatz Leighton, *My Thirty Years Backstairs at the White House* (New York: Fleet, 1961), 133.

63 Jhan Robbins, *Bess and Harry: An American Love Story* (New York: Putnam, 1980), 38.

64 Jacqueline Kennedy Onassis, quoted in Caroline Kennedy, *The Best-Loved Poems of Jacqueline Kennedy Onassis* (New York: Grand Central, 2015), 168.

65 Barbara Bush, *Millie's Book: As Dictated to Barbara Bush* (New York: Quill, 1992), cover copy.

66 Ginny Stanford, quoted in Veronica Stracqualursi, "Painting the Powerful: Artists Share Process of Capturing Presidential Couples on Canvas," November 8, 2017, ABCNews.com.

67 Steve Johnson, "Amy Sherald Painted Michelle Obama, and It Became a Sensation. But Many People Didn't Get It, and to Her, That's Just Fine," *Chicago Tribune*, February 19, 2020, www.chicagotribune.com.

68 See Melania Trump's @FLOTUS Twitter account: https://twitter.com/FLOTUS/status/1243175999526838272.

Selected References

Adams, Louisa Catherine. *Diary and Autobiographical Writings of Louisa Catherine Adams*. 2 vols. Edited by Judith S. Graham and C. James Taylor. Cambridge, MA: Belknap Press of Harvard University Press, 2013.

Adams Papers Digital Edition. Massachusetts Historical Society. http://www.masshist.org/publications/adams-papers/.

Allgor, Catherine. *A Perfect Union: Dolley Madison and the Creation of the American Nation*. New York: Henry Holt and Company, 2007.

Black, Allida M. *The First Ladies of the United States of America*. 15th ed. Washington, D.C.: White House Historical Association, 2019.

Boller, Paul F. *Presidential Wives: An Anecdotal History*. New York: Oxford University Press, 1998.

Buell, Augustus C. *History of Andrew Jackson: Pioneer, Patriot, Soldier, Politician, President*. 2 vols. New York: Charles Scribner's Sons, 1904.

Caroli, Betty Boyd. *First Ladies: From Martha Washington to Michelle Obama*. Rev. ed. New York: Oxford University Press, 2010.

Cleveland, Rose Elizabeth. *Precious and Adored: The Love Letters of Rose Cleveland and Evangeline Simpson Whipple, 1890–1918*. Edited by Lizzie Ehrenhalt and Tilly Laskey. St. Paul: Minnesota Historical Society Press, 2019.

Coolidge, Grace. *Grace Coolidge: An Autobiography*. Edited by Lawrence E. Wikander and Robert H. Ferrell. Worland, WY: High Plains, 1992.

Duffey, E. B. *The Ladies' and Gentlemen's Etiquette: A Complete Manual of the Manners and Dress of American Society Containing Forms of Letters, Invitations, Acceptances, and Regrets*. Philadelphia: Porter and Coates, 1877.

First Ladies Research. First Ladies' National Library. http://www.firstladies.org/biographies/.

Geer, Emily Apt. *First Lady: The Life of Lucy Webb Hayes*. Kent, OH: Kent State University Press, 1984.

Gould, Louis L. *American First Ladies: Their Lives and Their Legacy*. New York: Garland, 1996.

Graddy, Lisa Kathleen, and Amy Pastan. *The Smithsonian First Ladies Collection*. Washington, D.C.: Smithsonian Books, 2014.

Grant, Julia Dent. *The Personal Memoirs of Julia Dent Grant (Mrs. Ulysses S. Grant)*. Edited by John Y. Simon. Carbondale: Southern Illinois University Press, 1975.

Hagner, Isabella. Memoirs of Isabella Hagner 1901–1905. White House collection, Isabella Hagner James Papers, Office of the Curator. Edited by Priscilla Roosevelt. White House Historical Association. https://www.whitehousehistory.org/memoirs-of-isabella-hagner-1901-1905.

Jefferson, Isaac Granger. *Memoirs of a Monticello Slave*. Edited by Rayford W. Logan. Charlottesville: University of Virginia Press, 1951.

Johnson, Lady Bird. *A White House Diary*. Austin: University of Texas Press, 2007.

Nelson, Anson, and Fannie Nelson. *Memorials of Sarah Polk: Wife of the Eleventh President of the United States*. New York: Anson D. F. Randolph, 1892.

Obama, Michelle. *Becoming*. New York: Crown, 2018.

Pine, Joslyn T. *Wit and Wisdom of America's First Ladies: A Book of Quotations*. Mineola, NY: Dover, 2014.

Reagan, Nancy. *My Turn: The Memoirs of Nancy Reagan*. New York: Random House, 2011.

Robbins, Jhan. *Bess and Harry: An American Love Story*. New York: Putnam, 1980.

Roberts, Cokie. *Founding Mothers: The Women Who Raised Our Nation*. New York: Harper Collins, 2018.

Schneider, Dorothy, and Carl J. Schneider. *First Ladies: A Biographical Dictionary*. 3rd ed. New York: Facts on File, 2010.

Schwartz, Marie Jenkins. *Ties that Bound: Founding First Ladies and Slaves*. Chicago: University of Chicago Press, 2017.

Shaw, John, ed. *Crete and James: Personal Letters of Lucretia and James Garfield*. East Lansing: Michigan State University Press, 1994.

Sibley, Katherine A. S., ed. *A Companion to First Ladies*. Malden, MA: John Wiley and Sons, 2016.

Smith, Nancy Kegan, and Mary C. Ryan. *Modern First Ladies: Their Documentary Legacy*. Washington, D.C.: National Archives and Records Administration, 1989.

Swain, Susan. *First Ladies: Presidential Historians on the Lives of Forty-Five Iconic American Women*. New York: PublicAffairs, 2015.

Taft, Mrs. William Howard. *Recollections of Full Years*. New York: Dodd, Mead, and Company, 1914.

Troy, Gil. *Affairs of State: The Rise and Rejection of the Presidential Couple Since World War II*. New York: Free Press, 1997.

Washington, Martha. "Martha Washington: A Life." George Washington's Mount Vernon and Center for History and New Media. http://marthawashington.us/items.

Watson, Robert P. *American First Ladies*. 3rd ed. Ipswich, MA: Salem Press, 2015.

Watson, Robert P., and Anthony J. Eksterowicz, eds. *The Presidential Companion: Readings on the First Ladies*. Columbia: University of South Carolina Press, 2006.

Wilson, Edith Bolling. *My Memoir*. New York: Arno Press, 1980. First published 1939 by Bobbs-Merrill Company.

Measurements

Unless otherwise noted, measurements indicate stretcher size for paintings, image size for photographs, and sheet size for other works on paper.

Index of Subjects

Index of Artists

Acknowledgments

This publication and the accompanying exhibition *Every Eye Is Upon Me: First Ladies of the United States* were realized through the collaboration and generosity of numerous individuals and institutions. Under the leadership of the National Portrait Gallery's director Kim Sajet, I was fortunate to work alongside an excellent team.

For their exceptional editing of the publication, I express special thanks to Rhys Conlon and Sarah McGavran. Mark Gulezian, Allison Keilman, and Erin Beasley ensured high-quality illustrations. At Smithsonian Books, I am grateful for the support of Carolyn Gleason and her team, particularly Jaime Schwender, who managed the project gracefully in uncertain times. We were very fortunate to work with designers Antonio Alcalá and Marti Davila of Studio A and benefitted from the skills of copyeditor Carla Borden.

Also at the museum, I thank Jacqueline Petito, Tibor Waldner, Claire Kelly, Peter Crellin, Jennifer Moran, Lindsay Gabryszak, Rebecca Kasemeyer, Deb Sisum, Kaia Black, Marissa Olivas, Jennifer Wodzianski, Wayne Long, and Dale Hunt. And special thanks to my curatorial colleagues: Dorothy Moss, in her role as coordinating curator of the Smithsonian American Women's History Initiative, and Chief Curator Emerita Brandon Brame Fortune, who conceived the project before her retirement in the summer of 2020.

I am extremely grateful to the curatorial staff of the White House for access to portraits in the executive mansion, and to the staff of the National First Ladies' Library, for research assistance and biographical outlines.

I thank the following lenders: Sarah Chapman; Fenimore Art Museum; Forbes Library; Andrew Jackson Foundation; Halton Family Collection; Thomas Jefferson Foundation at Monticello; Andrew Johnson National Historic Site, National Park Service; John F. Kennedy Presidential Library and Museum; Library of Congress; Museum of the City of New York; National First Ladies' Library; National Museum of American History, Smithsonian Institution; Michelle Obama; President James K. Polk Home and Museum; Ronald Reagan Presidential Library and Museum; Smithsonian American Art Museum; US Department of State; Martin Van Buren National Historic Site, National Park Service; The White House; Winchester-Frederick County Historical Society, Winchester, Virginia; and President Woodrow Wilson House, A Site of the National Trust for Historic Preservation.

The American Women's History Initiative focuses on *Her Story* at the Smithsonian through our collections and our exhibitions, and I am proud that *Every Eye Is Upon Me: First Ladies of the United States* is part of such an important endeavor.

Unless otherwise noted below or in figure captions, all images are from the National Portrait Gallery, Smithsonian Institution.

Published by Smithsonian Books in association with the National Portrait Gallery, Smithsonian Institution

Smithsonian Books
Director: Carolyn Gleason
Senior Editor: Jaime Schwender
Assistant Editor: Julie Huggins

National Portrait Gallery
Head of Publications: Rhys Conlon
Editor: Sarah McGavran
Photographer: Mark Gulezian

Copyedited by Carla M. Borden

Designed by Studio A

This book may be purchased for educational, business, or sales promotional use. For information, please write:

Special Markets Department, Smithsonian Books, P.O. Box 37012, MRC 513, Washington, DC 20013

Library of Congress Cataloging-in-Publication Data

Names: National Portrait Gallery (Smithsonian Institution), author. | Shaw, Gwendolyn DuBois, 1968-author.

Title: First ladies of the United States / National Portrait Gallery, Gwendolyn DuBois Shaw.

Description: Washington, DC : Smithsonian Books, published in association with the National Portrait Gallery, [2020] | Includes bibliographical references.

Identifiers: LCCN 2020026246 | ISBN 9781588346940 (paperback)

Subjects: LCSH: Presidents' spouses—United States—Biography. | Presidents' spouses—United States—Portraits.

Classification: LCC E176.2 .N39 2021 | DDC 973.09/9 [B]--dc23

LC record available at https://lccn.loc.gov/2020026246

Printed in Singapore, not at government expense
24 23 22 21 20 1 2 3 4 5